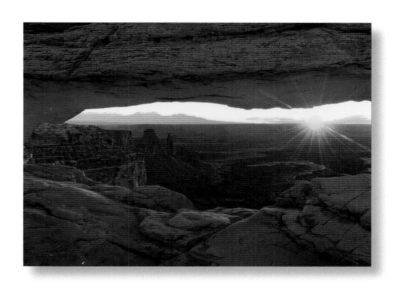

UTAH

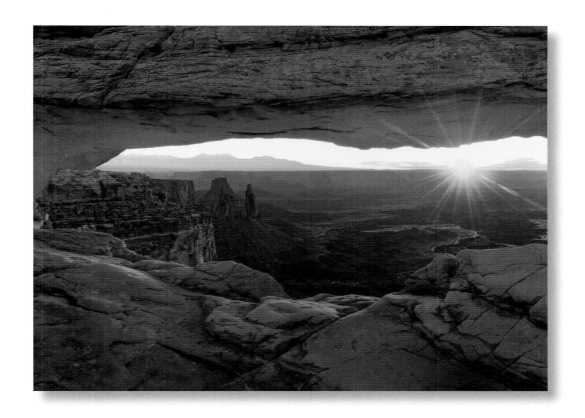

AMERICA SERIES

Text by Helen Stortini
Edited by Ben D'Andrea
Photo editing by Helen Stortini
Cover and interior design by Steve Penner
Typeset by Helen Stortini

Printed and bound in China.

Library and Archives Canada Cataloguing in Publication

Stortini, Helen
 Utah/Helen Stortini.

(America series)
ISBN 978-1-94041-626-7

 1. Utah—Pictorial works. I. Title. II. Series.

F827.S76 2006 979.2'034'0222 C2006-900327-0

For more information on the America Series titles, please visit Midpoint Trade Books at
www.midpointtrade.com.

From the salt-encrusted shores of Great Salt Lake to the snow-capped peaks of the Uinta Mountains and from the lush farmland of the Fruitway to the world-famous silhouette of Delicate Arch, Utah is filled with some of the earth's most dramatic landscapes.

An outdoor enthusiast's paradise, Utah is home to barren deserts, majestic canyons, lush forests, and soaring mountains. With five National Parks and Wasatch Mountain's Olympic-class skiing, this diverse state has something for everyone. Visitors travel from around the world to hike through the brilliant red sandstone formations of the southwest and hit the slopes with the "best snow on earth" in the north.

Aptly named the "Beehive State," Utah was founded by industrious and persevering pioneers. Faced with religious persecution, Brigham Young led a group of Mormon settlers from Nauvoo, Illinois, to what is now Salt Lake City. The group traveled almost 1,300 miles in search of a new home, enduring harsh conditions across five states. Between 1847 and 1869, roughly 70,000 Mormons followed in their footsteps to carve out an existence in Utah's rugged wilderness. Their efforts resulted in numerous thriving communities across the state. Today, more than 60 percent of Utah belongs to the Church of Jesus Christ of Latter-day Saints. Utah is filled with historic sites, such as restored communities and preserved homesteads, that pay tribute to the efforts of these early pioneers.

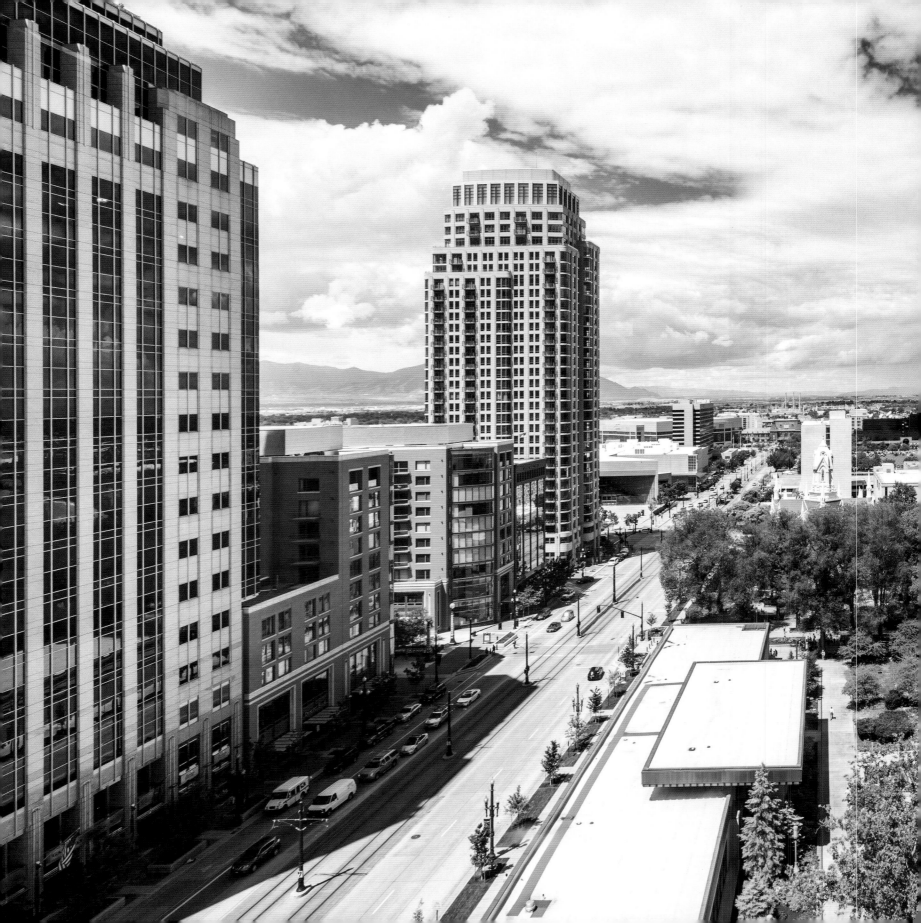

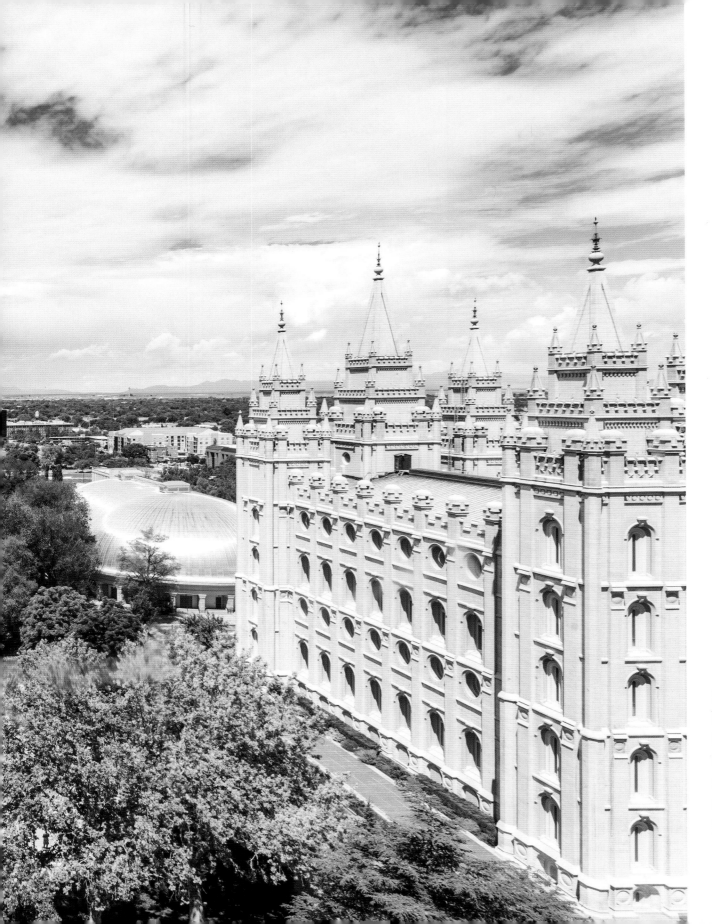

Nestled at the base of the Wasatch Mountains, Salt Lake City—Utah's capital—is home to more than 180,000 people.

An outdoor enthusiast's paradise, the town of quiet Moab provides access to Arches National Park, Canyonlands National Park, and Dead Horse Point State Park. With its stunning natural surroundings, the town offers hiking, mountain biking, and kayaking.

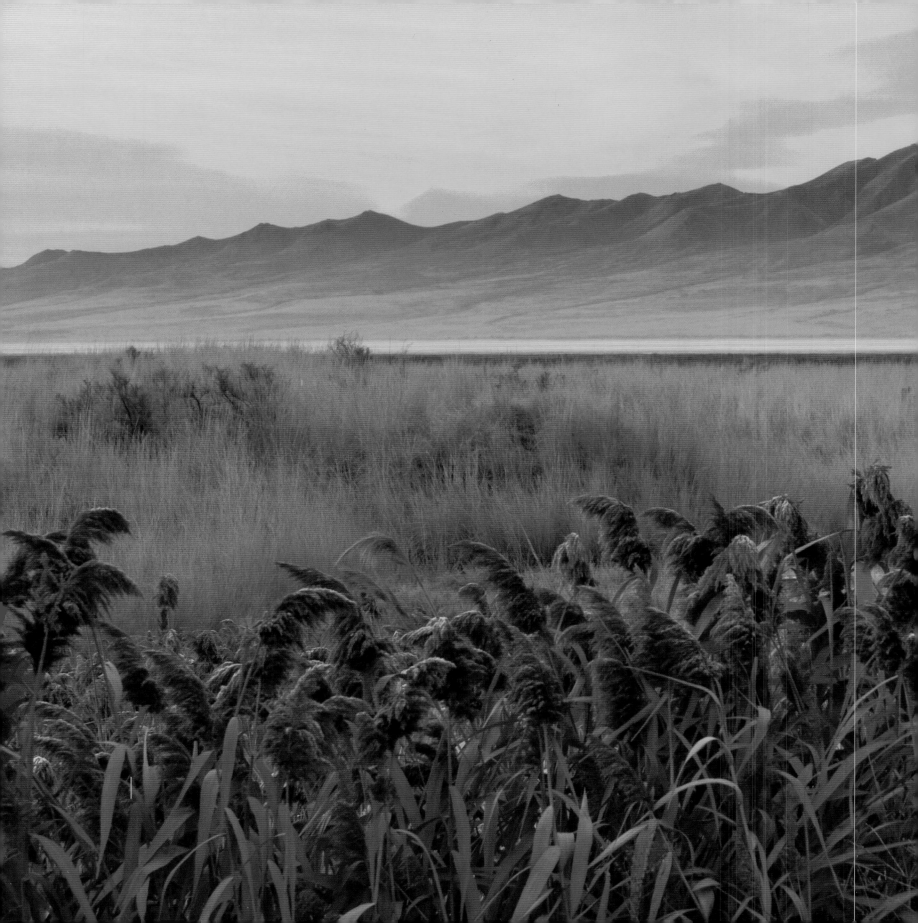

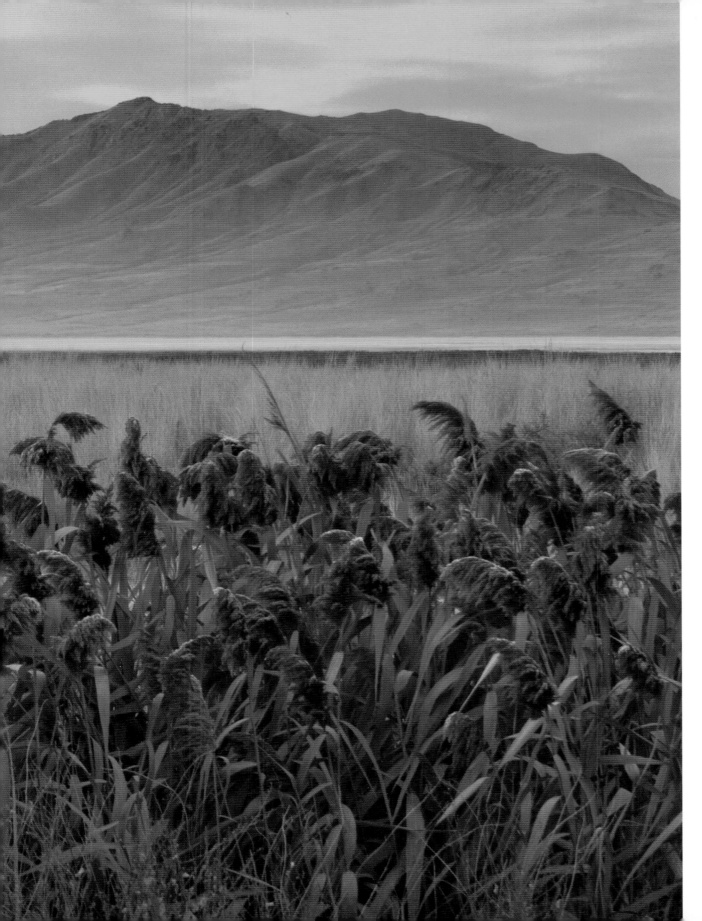

Popular with outdoor enthusiasts, Antelope Island offers more than 28,000 acres of pristine, natural surroundings. The island is home to an array of wildlife, including a herd of more than 600 American Bison introduced to the island in 1893.

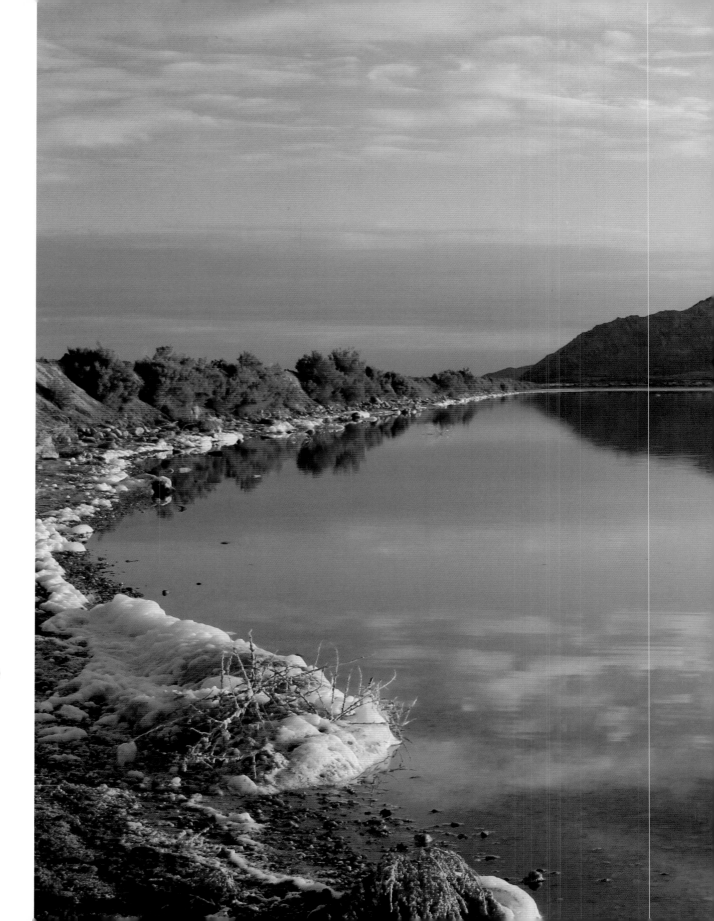

A remnant of ancient Lake Bonneville, Great Salt Lake contains so much salt because it has no outlet to the sea. The lake's salt content varies from 9 to 28 percent, making it saltier than the ocean.

12

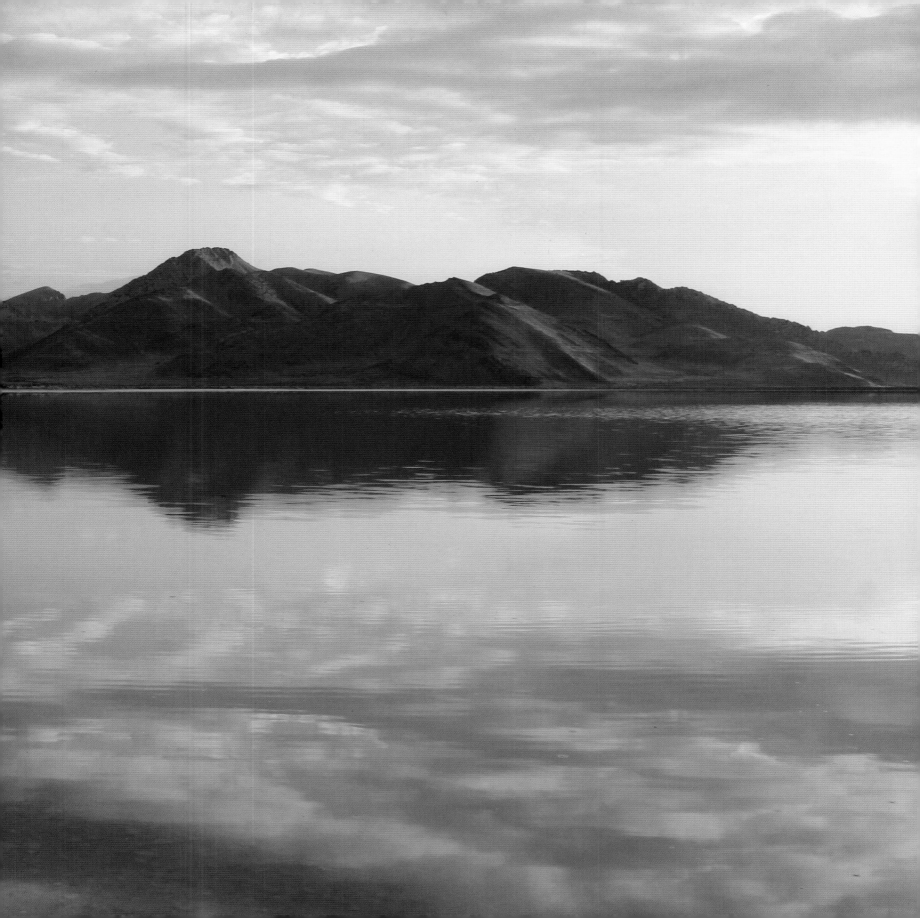

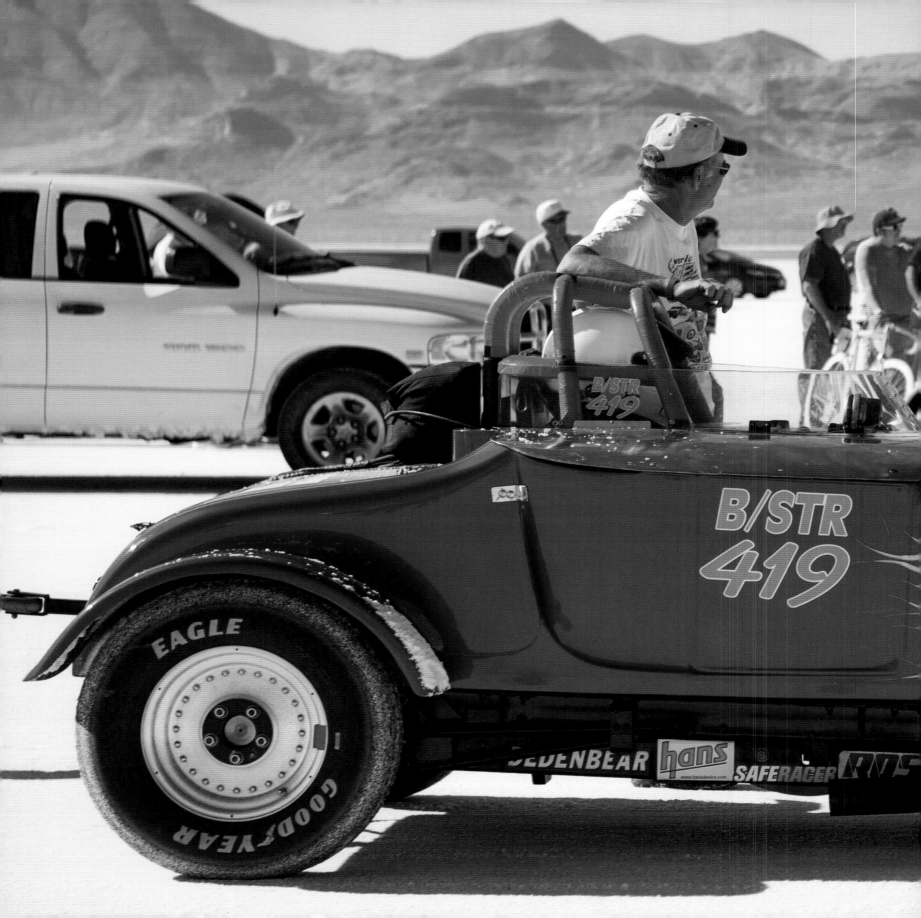

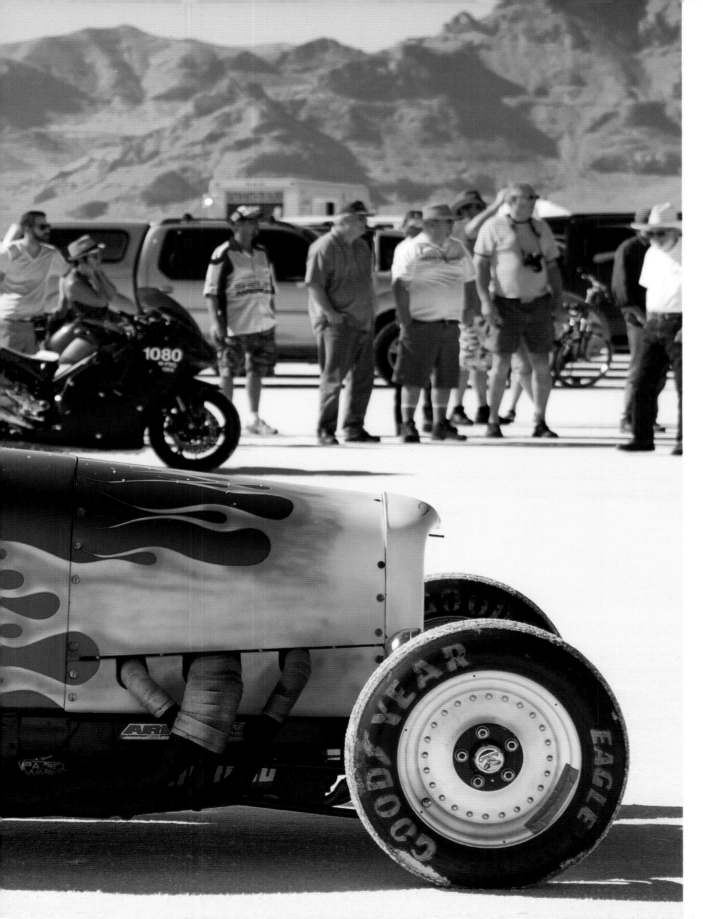

A 30,000 acre salt pan, or an expanse of flat land created from various minerals, exists within Utah. Known as the Bonneville Salt Flats, this public land contains the Bonneville Salt Flats Speedway, a road used for many automobile and motorcycle speed races. Most of these races, such as the pictured World of Speed event, are open to the public.

15

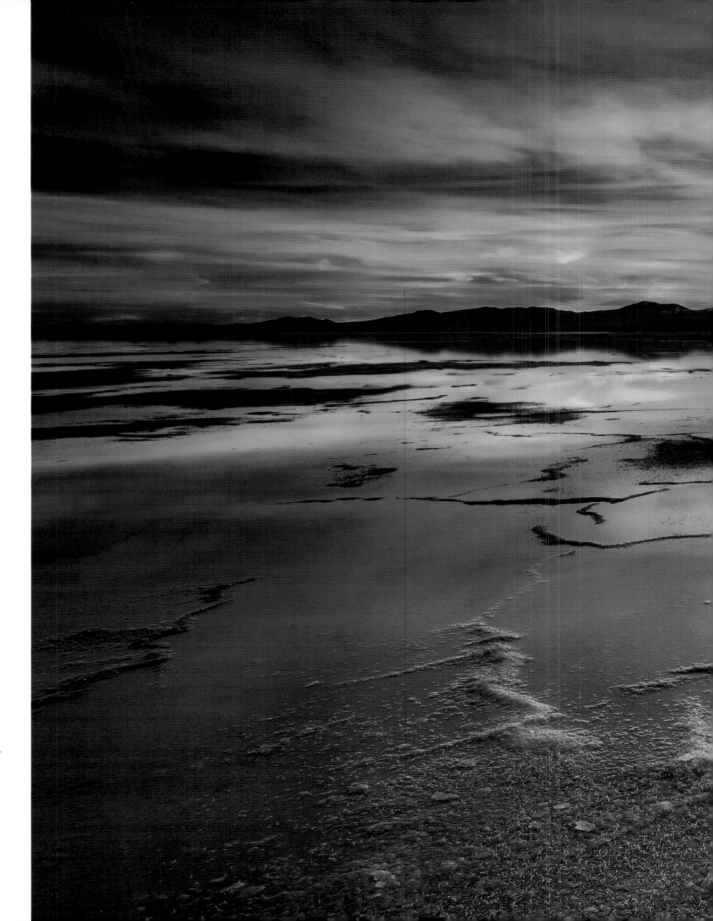

The sands of Great Salt Lake Desert are white from the salt deposited by the extinct Lake Bonneville. Covering 4,000 square miles, the desert stretches from Great Salt Lake to the Nevada border.

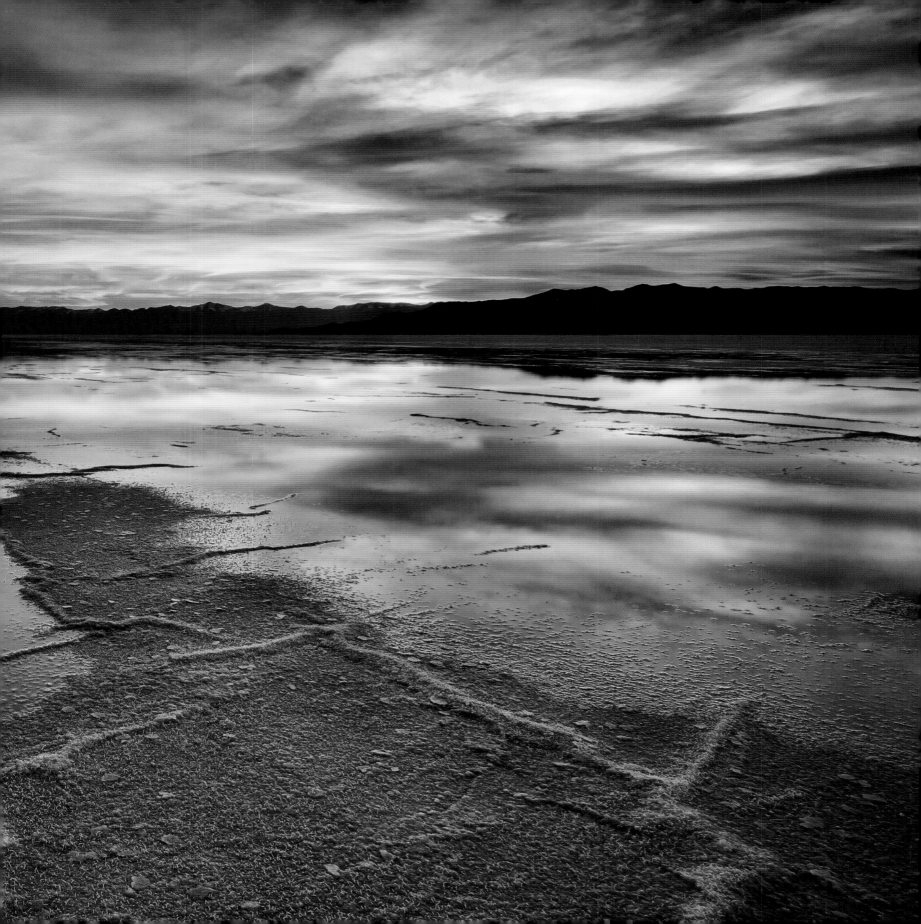

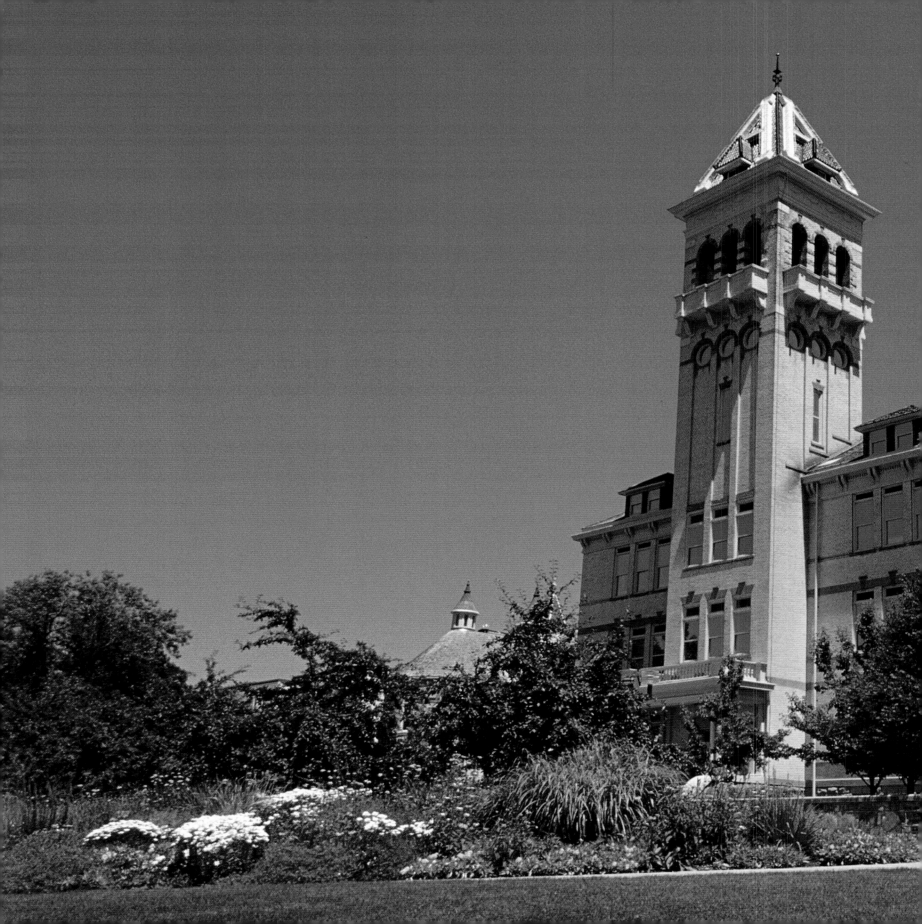

Founded in 1888,
Utah State University
has over 23,000
undergraduate and
graduate students
and offers over 200
majors.

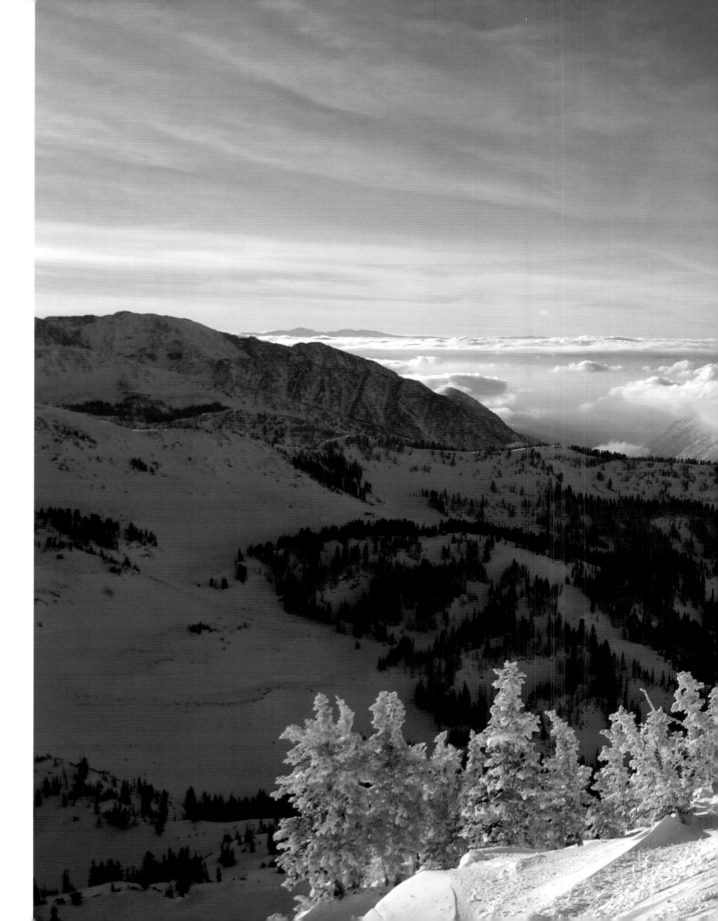

The snow in Utah
is unusually dry,
earning it a reputa-
tion as the "Greatest
Snow on Earth."

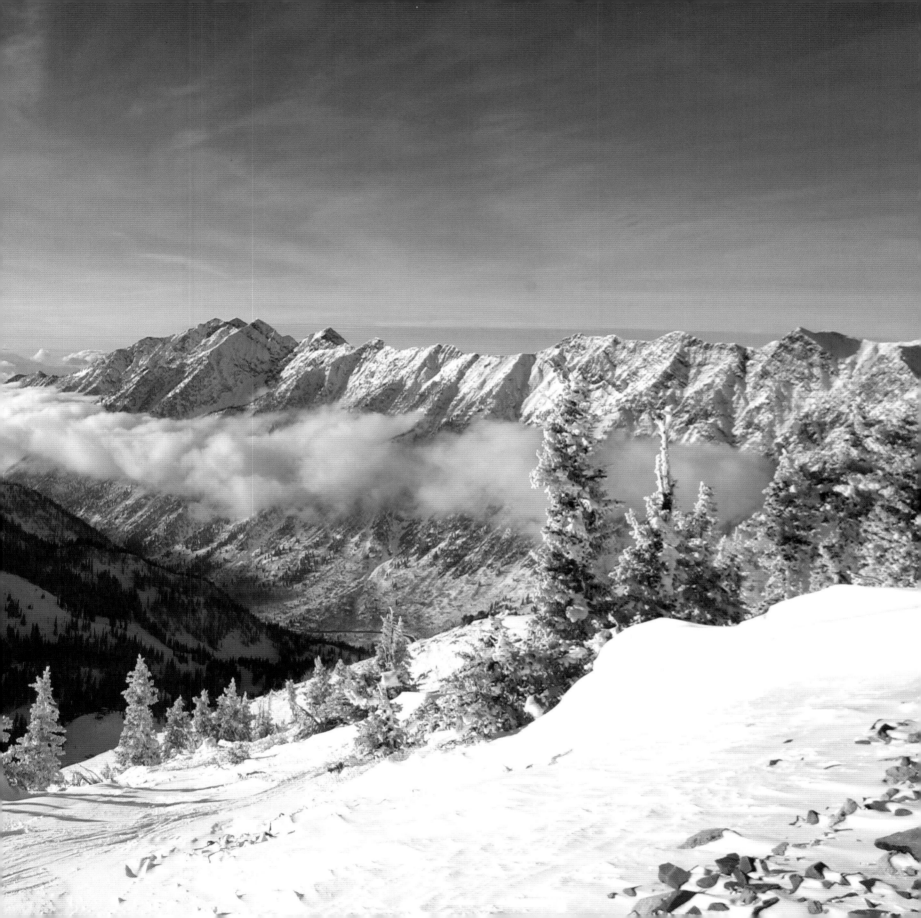

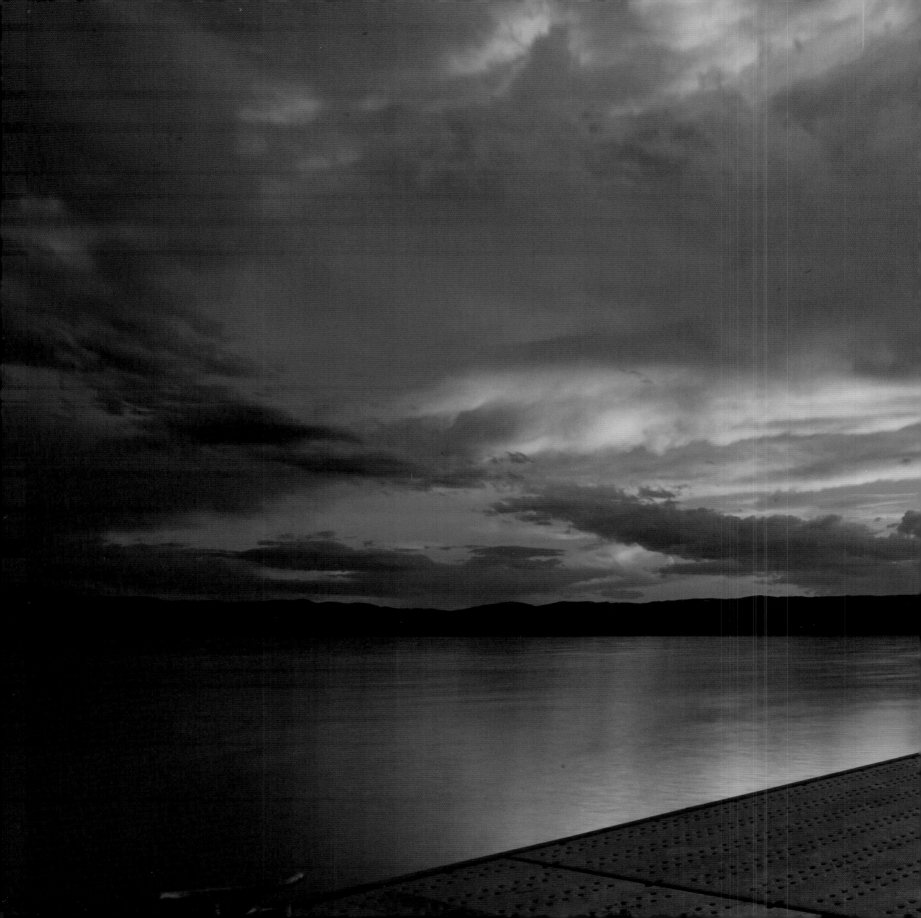

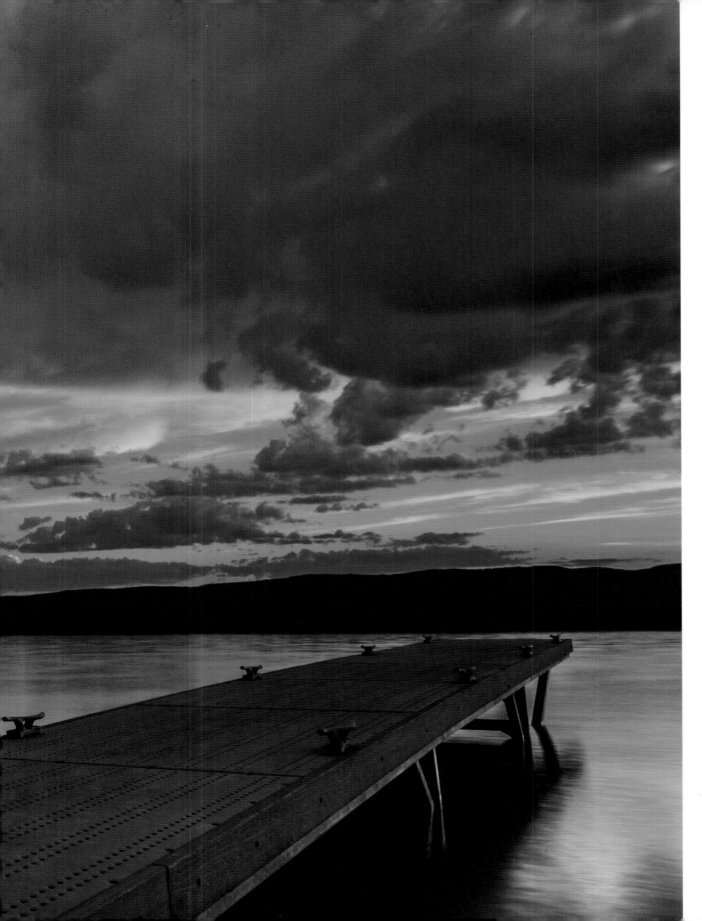

The brilliant turquoise color of Bear Lake results from limestone particles suspended in the water. Boaters, swimmers, and fishermen all take advantage of the 20-mile-long lake.

The Wasatch-Cache
National Forest
occupies almost
1.3 million acres.
Popular with skiers,
hikers, and campers,
this diverse forest
contains seven
wilderness areas and
is one of the most
visited forests in
the country.

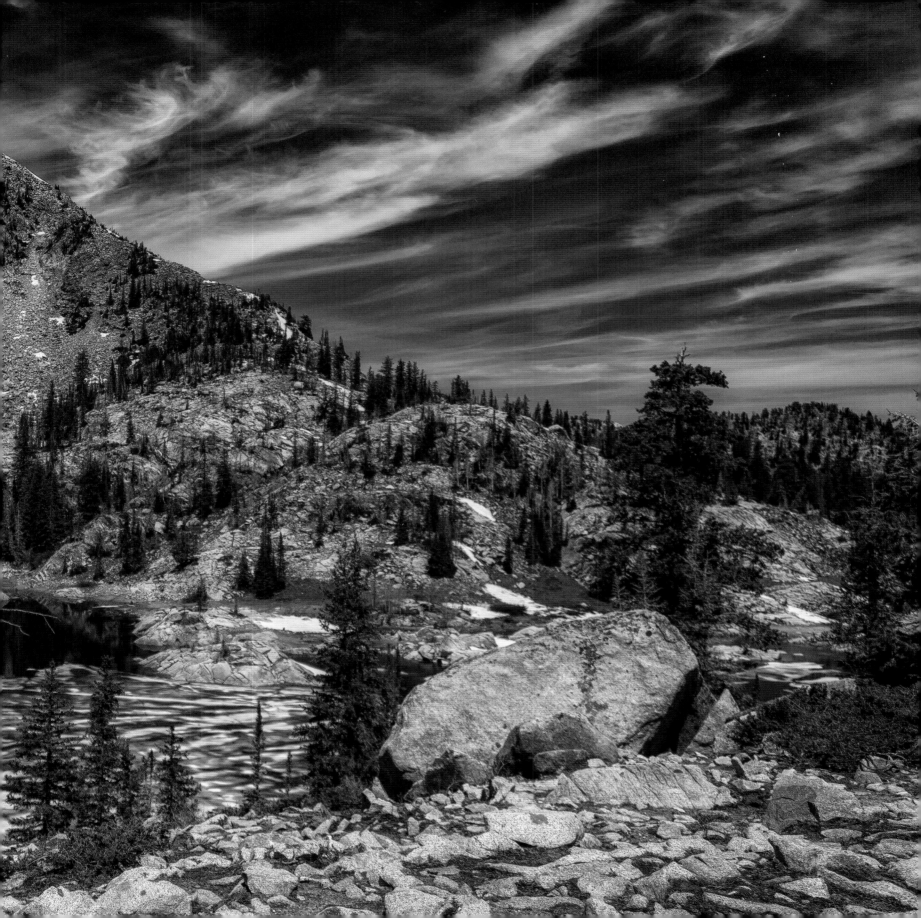

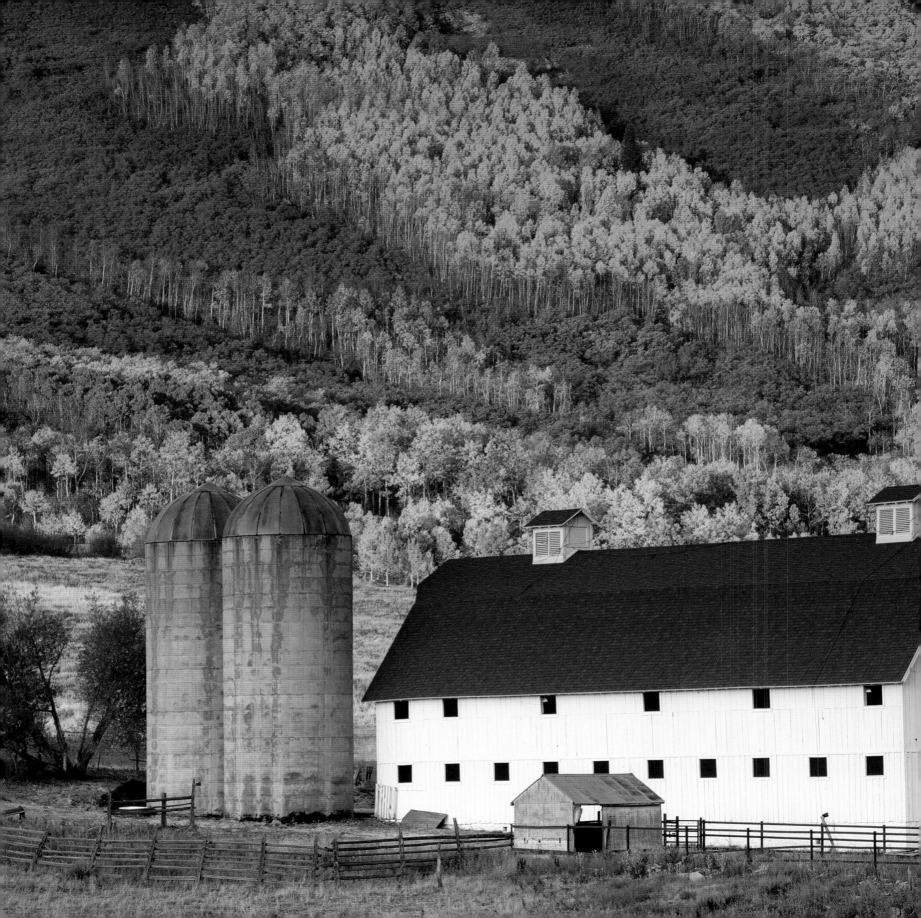

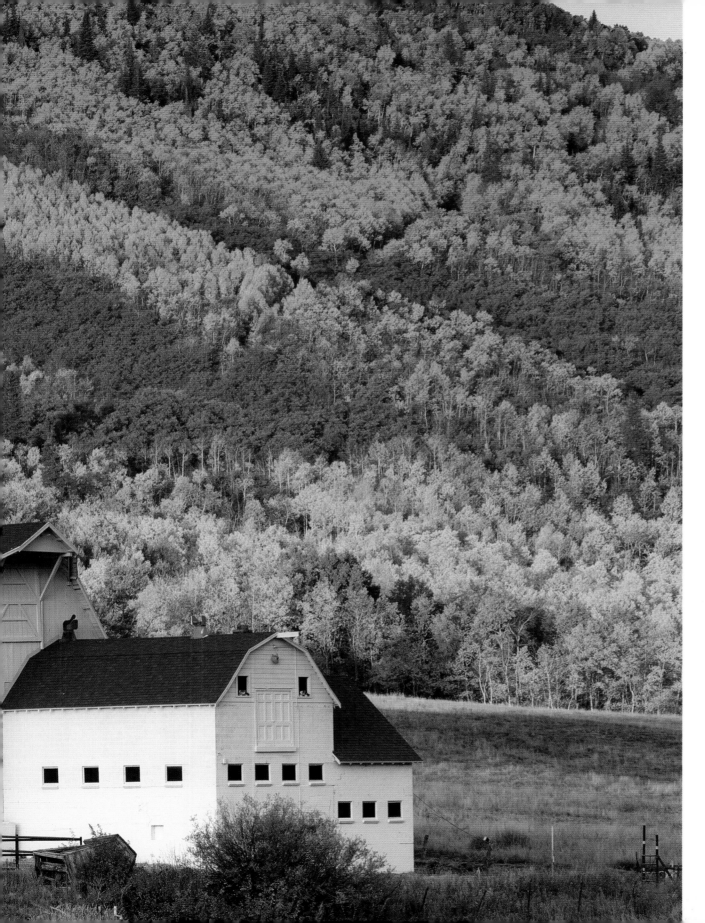

Utah's largest agri-
cultural commodities
include cattle, dairy,
hay, and hogs.

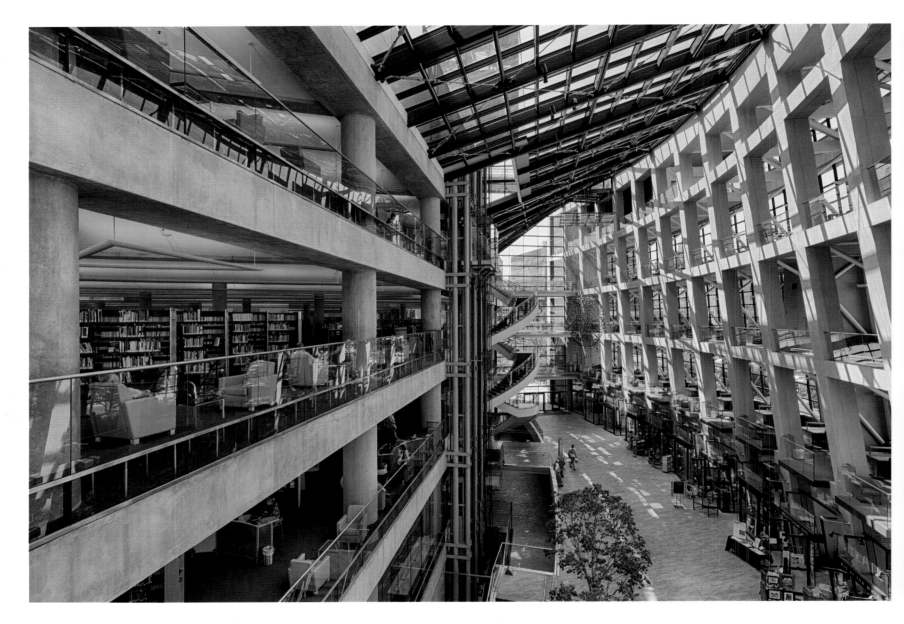

Noted for its creative architectural design, Salt Lake City's Main Library houses more than 500,000 books, contains a 300-seat auditorium, and provides multiple reading galleries. The library relies heavily upon natural lighting, stemming primarily from its curving five-story glass wall.

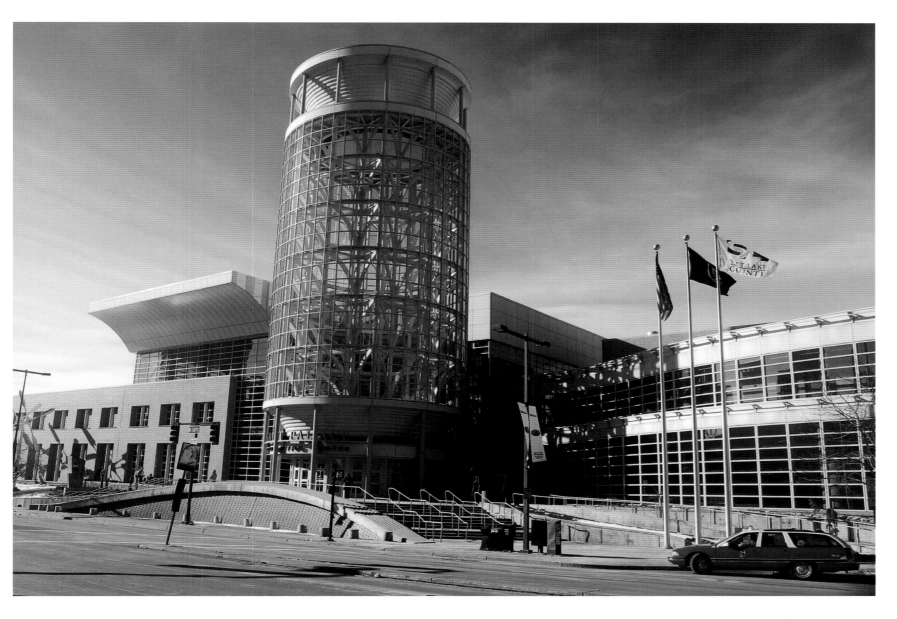

The Calvin L. Rampton Salt Palace Convention Center is located in the heart of Salt Lake City. The convention center provides over 515,000 square feet of exhibit hall space, a grand ballroom, and an in-house catering service. In 2002, the Salt Palace served as the Olympic Media Center.

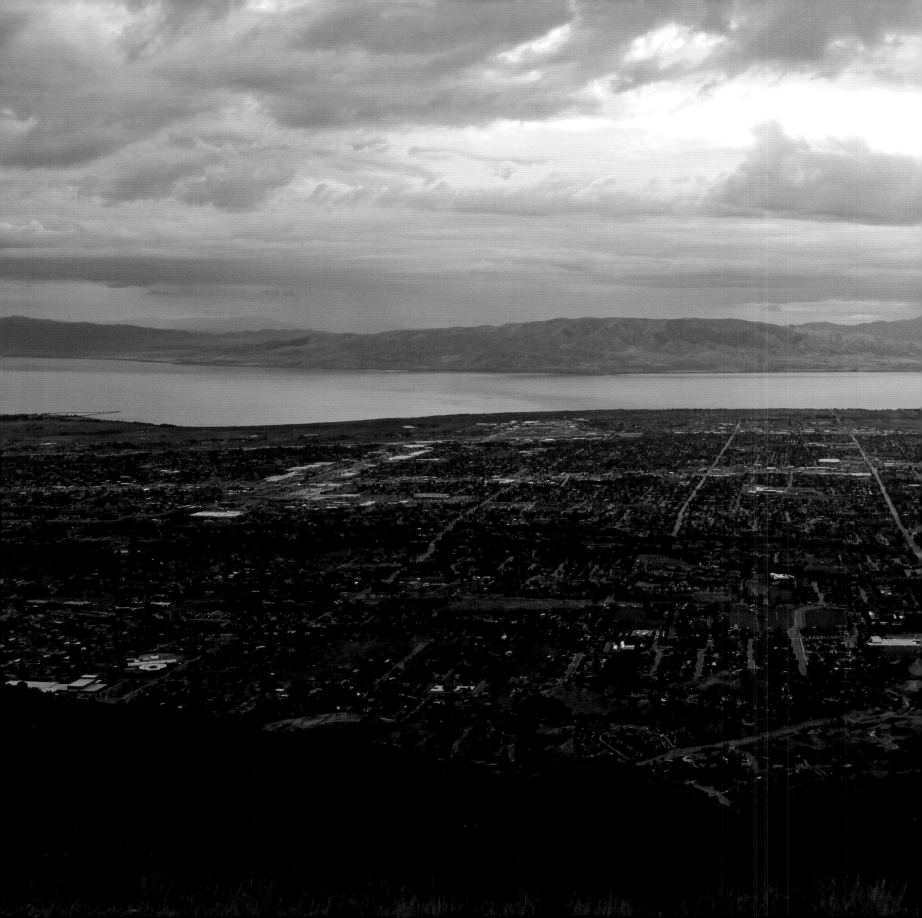

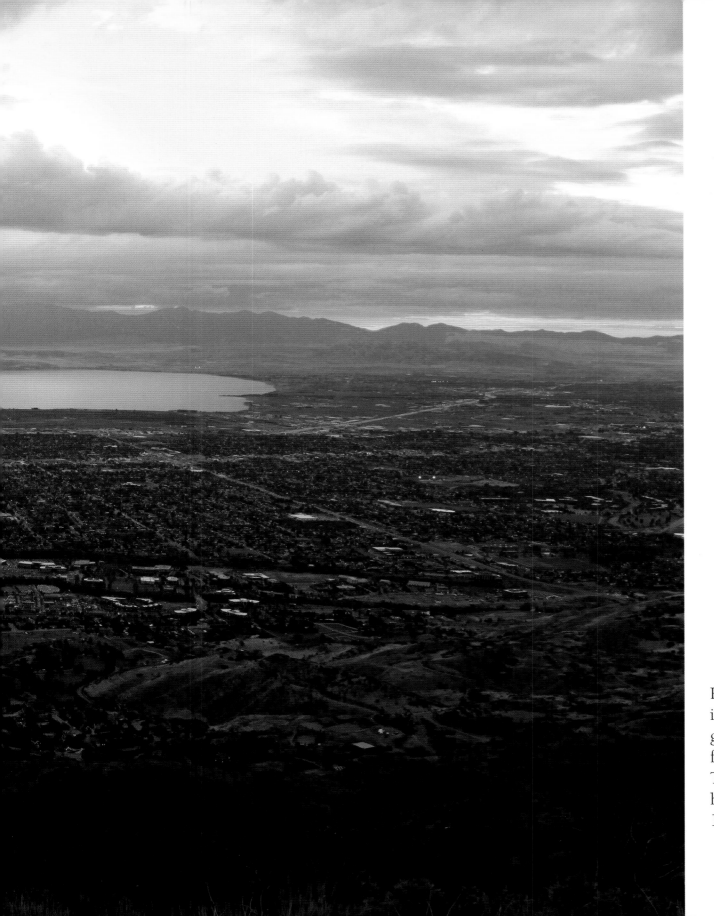

Provo was settled in 1849 by a small group of Mormons from Salt Lake City. The city is now home to more than 100,000 residents.

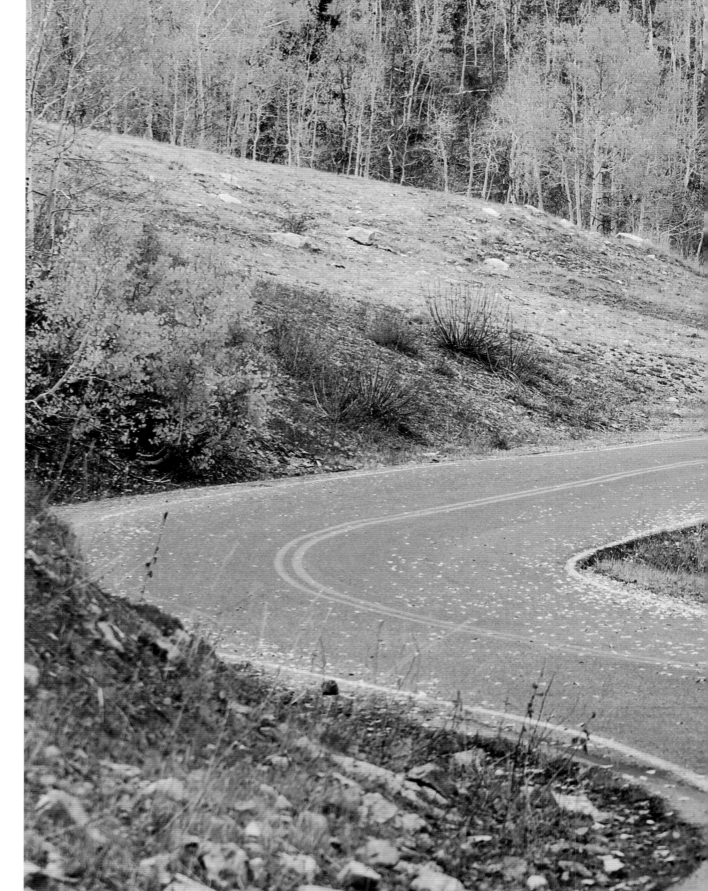

The Nebo Loop winds through Uinta National Forest between the towns of Nephi and Payson. Offering stunning views of the Wasatch Mountains and brilliant fall foliage, this scenic byway climbs over 9,000 feet in elevation.

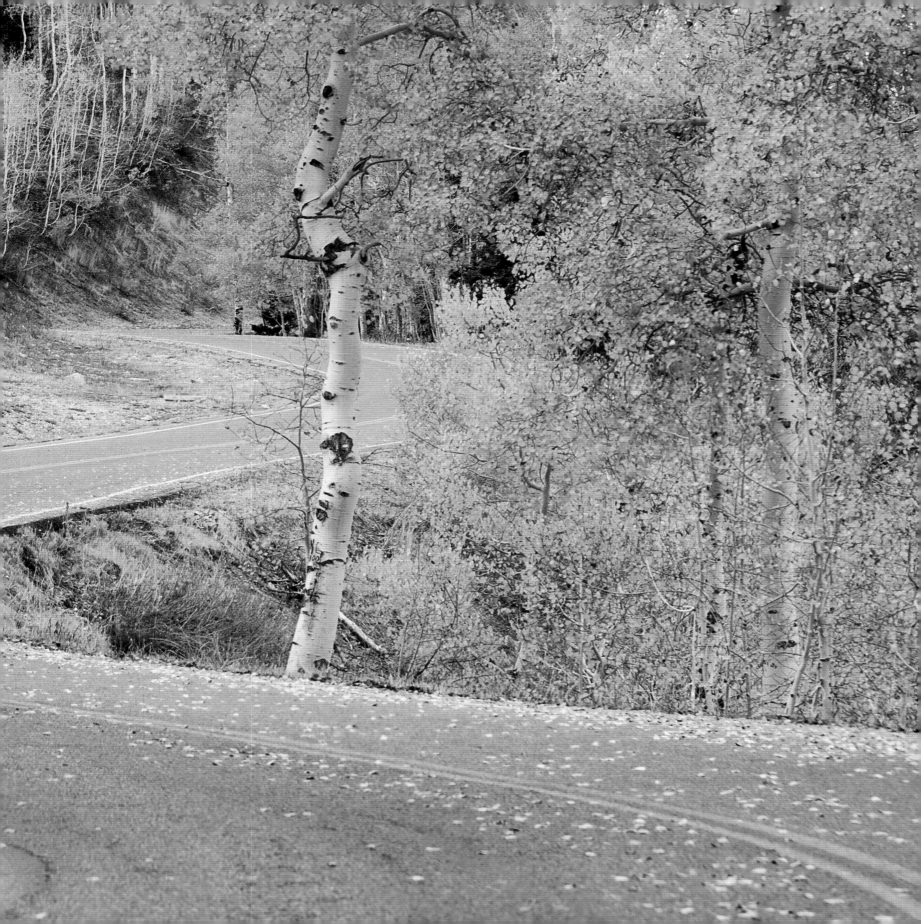

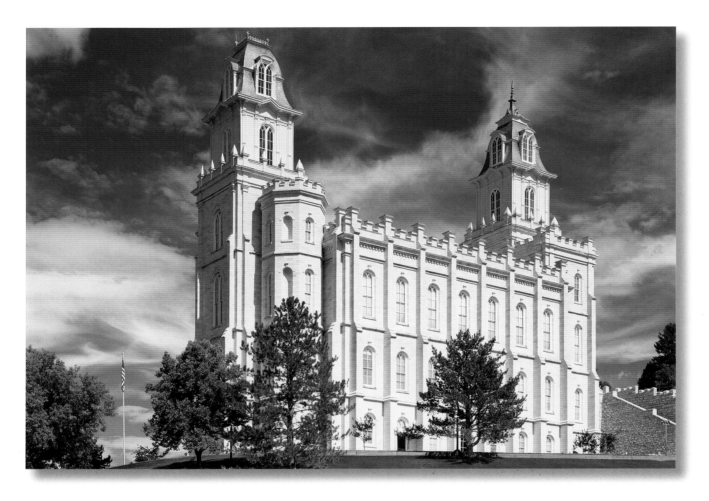

Built in 1888, the Manti Temple hosts the Mormon Miracle Pageant. Each
June, the temple grounds become a giant stage for a dramatic presentation
of Mormon beliefs.

Boasting an impressive 253,000 square feet, the Salt Lake Temple is the largest
temple built by the Church of Jesus Christ of Latter Day Saints (more commonly
referred to as the Mormon Church). The temple is located within Temple Square,
a complex that is owned by the Mormon Church.

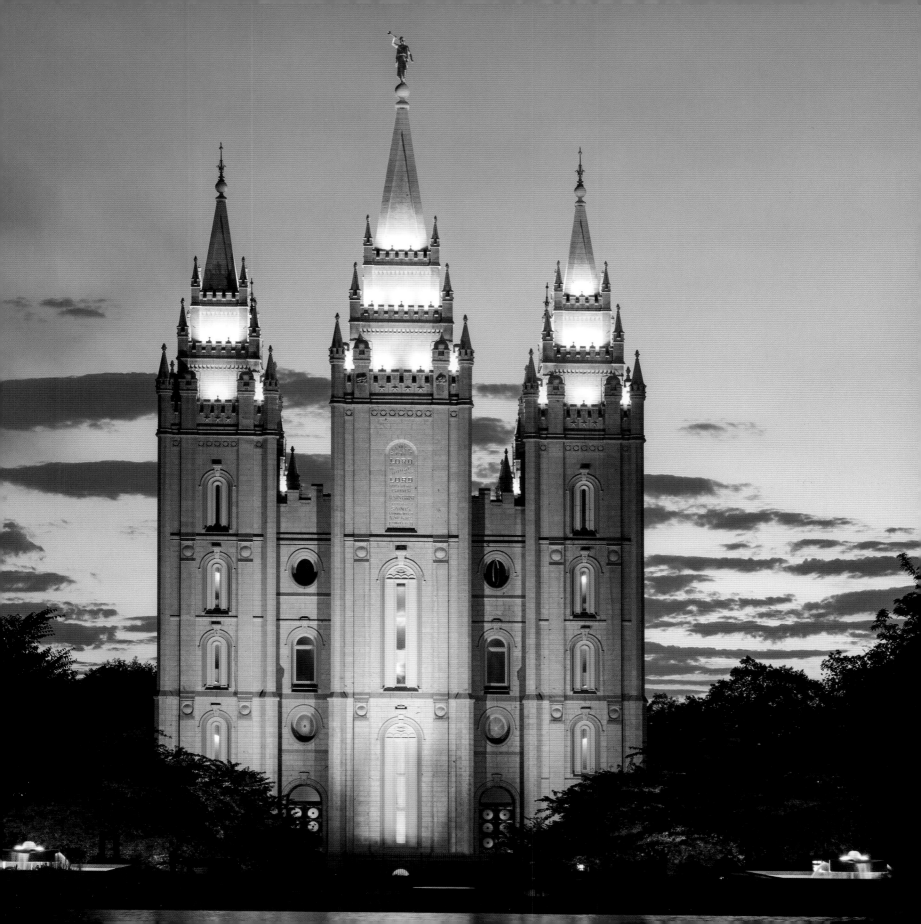

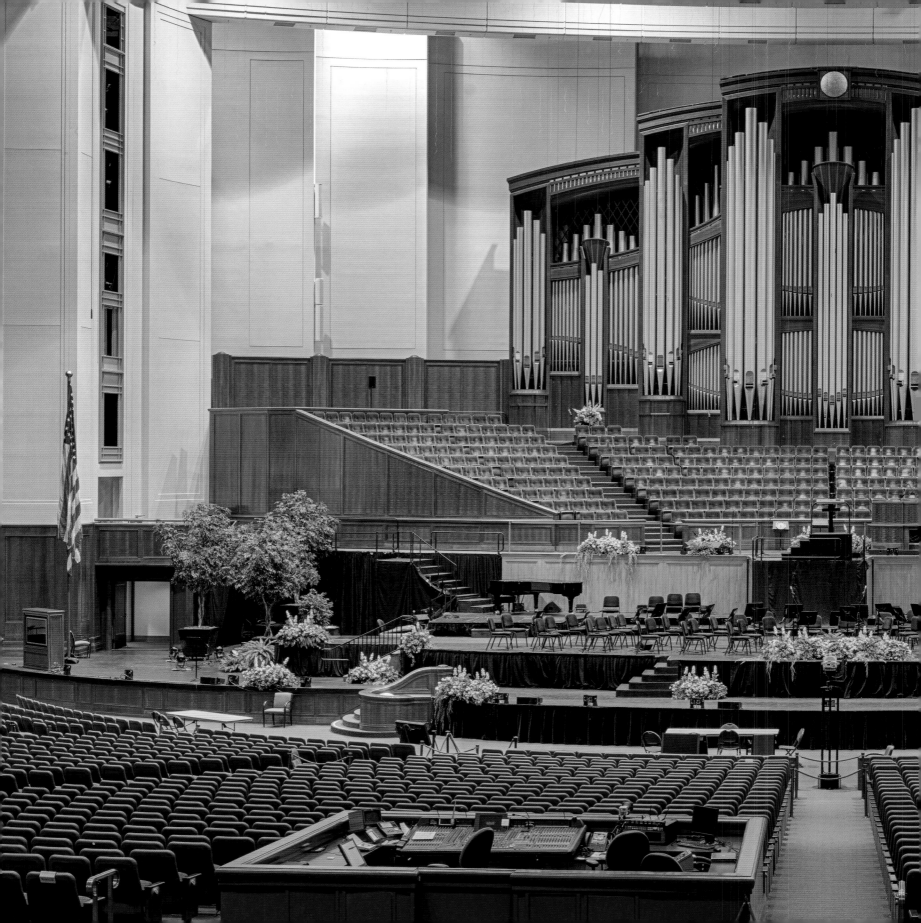

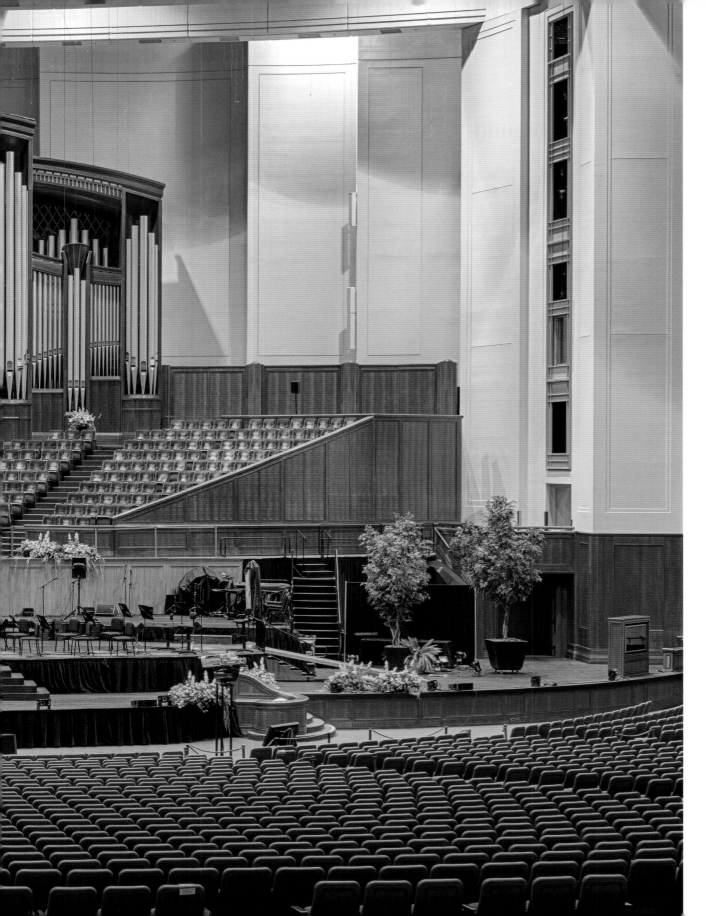

The Schoenstein Organ at the Conference Center is located within the Conference Center of the Church of Jesus Christ of Latter Day Saints. Composed of 7667 pipes, the organ is typically used to accompany the Mormon Tabernacle Chorus.

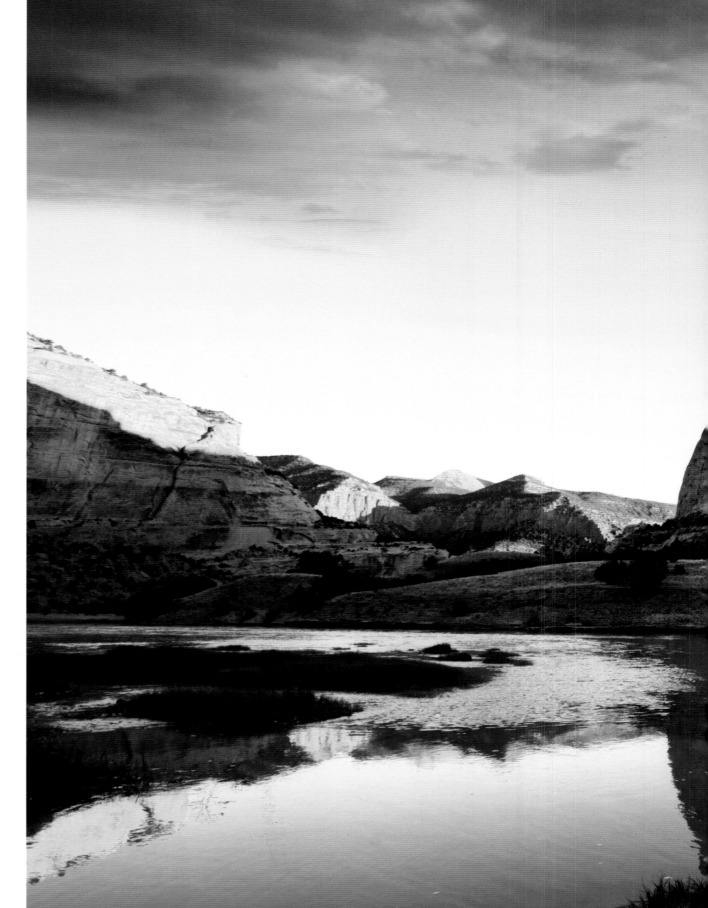

The rugged peaks of Split Mountain rise above Dinosaur National Park. Visitors can take in this breathtaking landscape while enjoying the park's camping facilities.

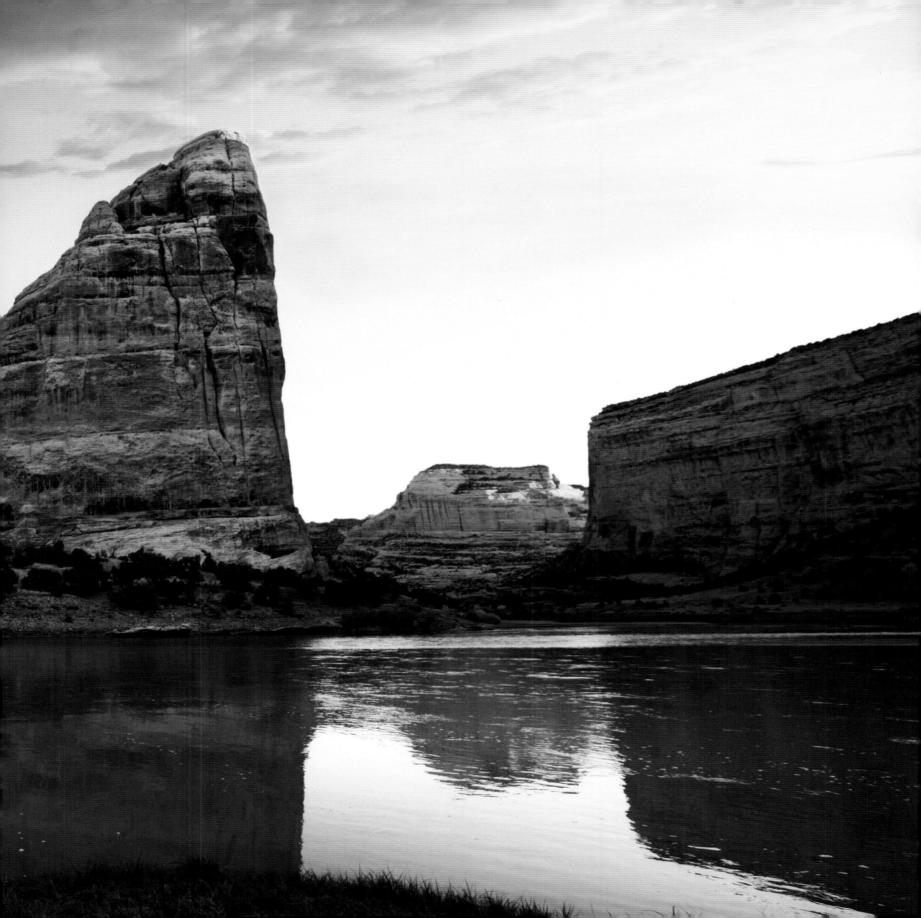

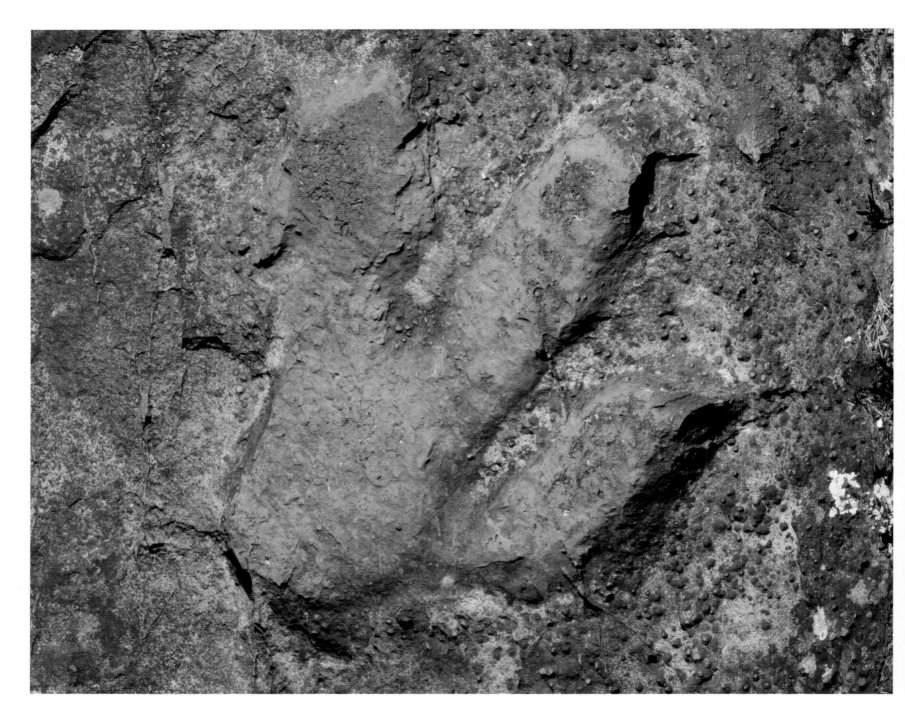

If you're looking for fossilized dinosaur tracks, such as the theropod footprint pictured above, then Utah's St. George Dinosaur Discovery Site at Johnson Farm, which boasts more than 3,500 tracks, is the place to be.

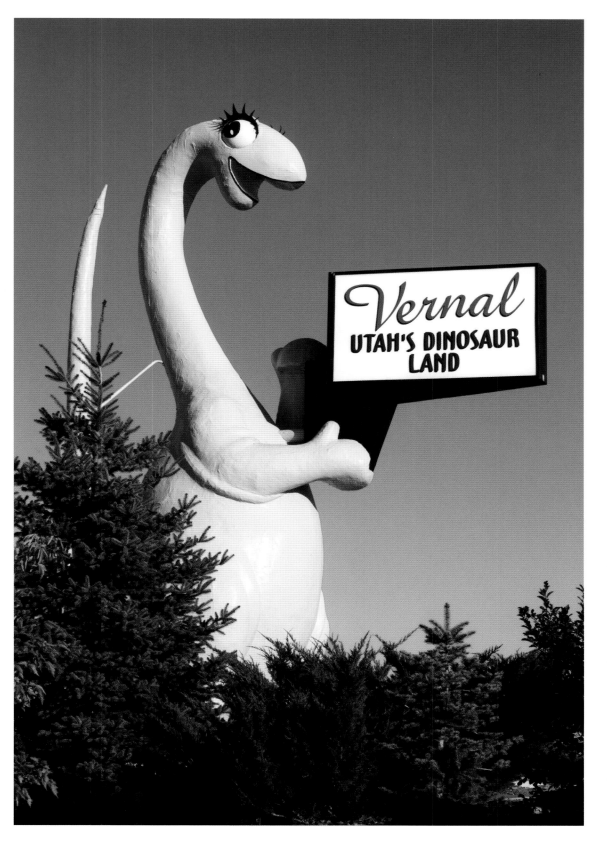

Vernal is home to a national monument, three state parks, and multiple museums. At Dinosaur Land, visitors can see more than 2,000 bones exposed in an open rock face inside the Quarry Visitor Center.

41

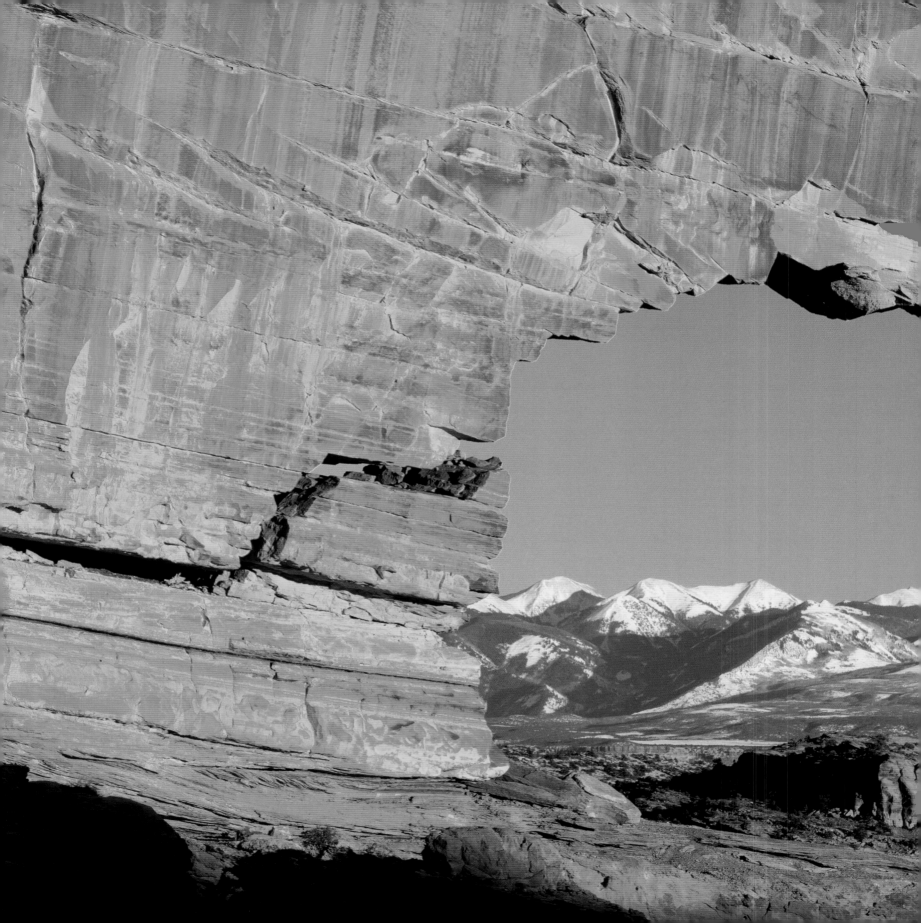

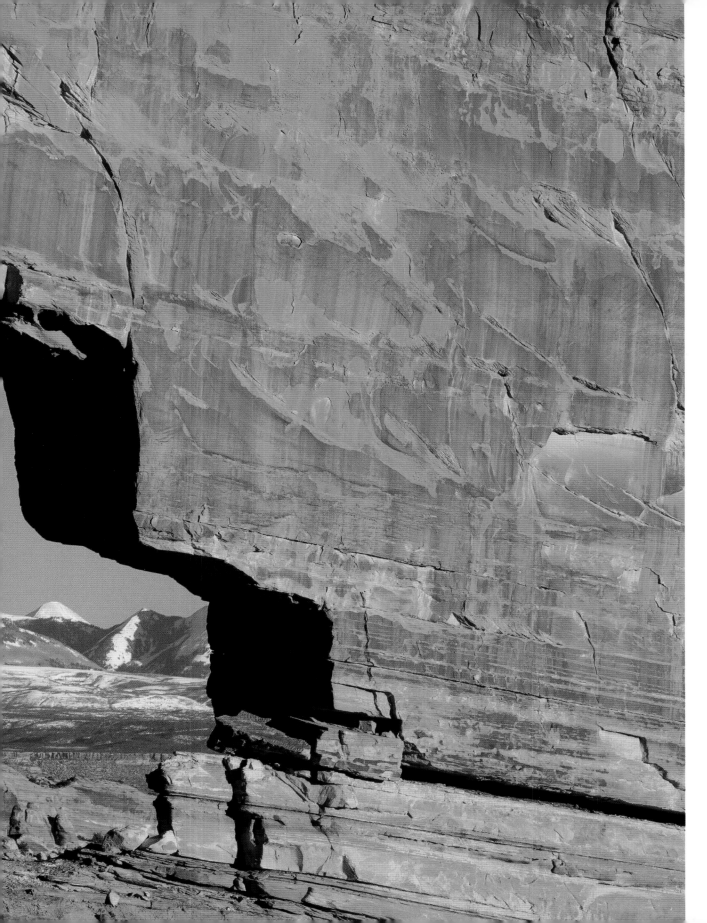

Named for the Jeep-shaped "window" in its rock face, Jeep Rock is part of a proposed 51,100-acre wilderness area, Behind the Rocks, that seeks to preserve the region's pristine natural environment.

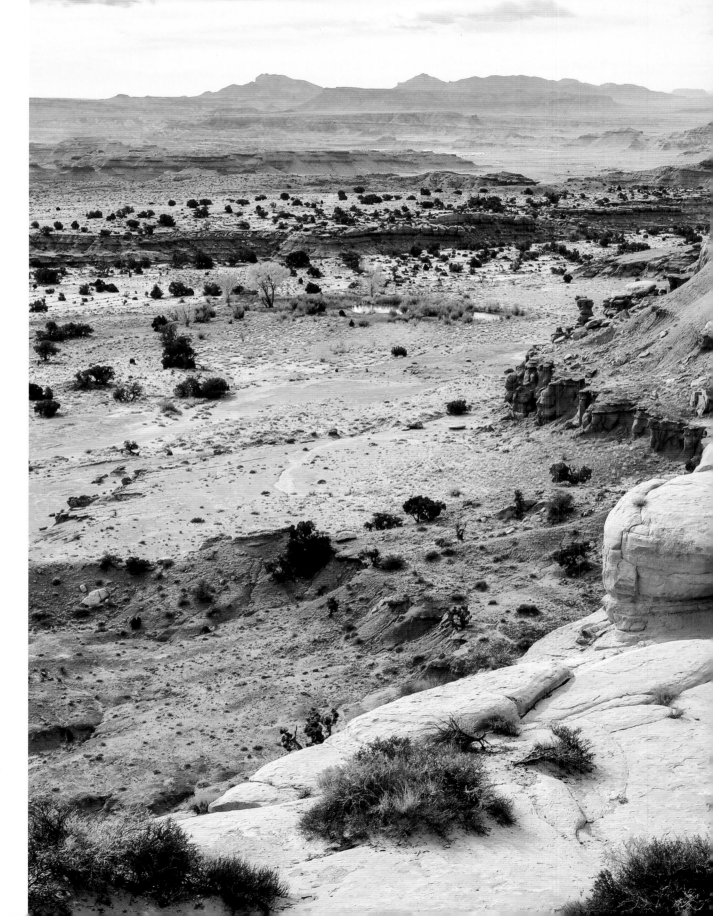

The San Rafael Swell is one of Utah's best-kept secrets. Few people visit the dramatic multi-hued rock formations, making it the ideal location for a solitary hike or undisturbed camping trip.

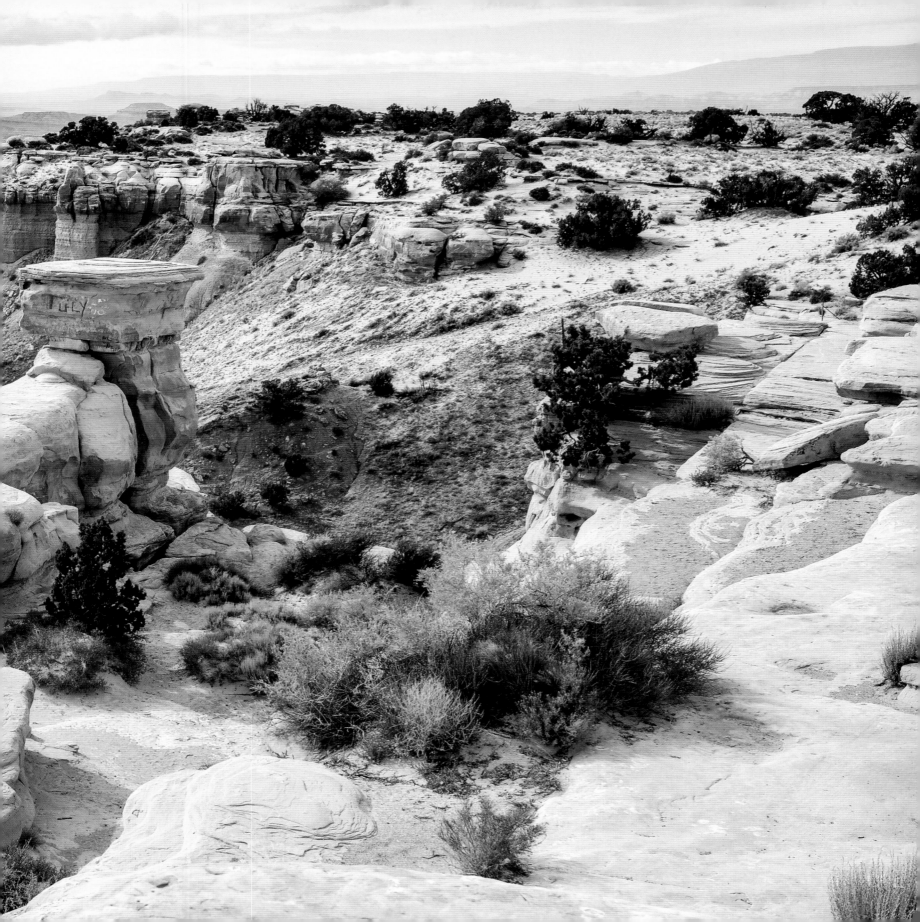

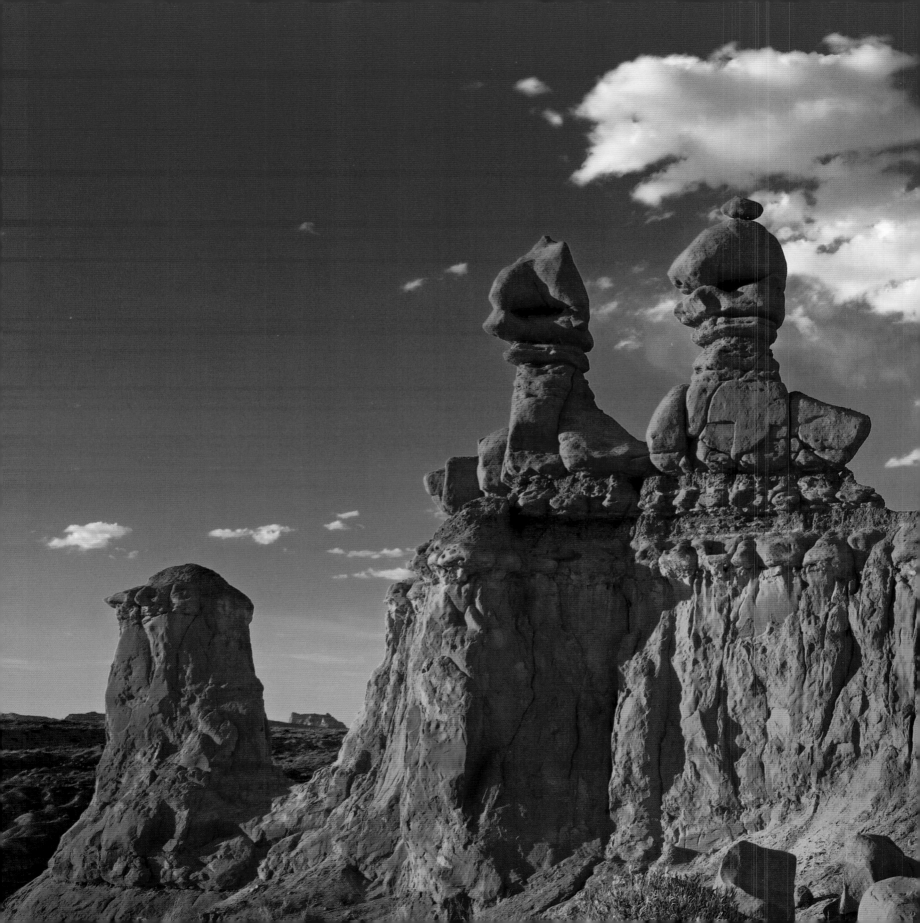

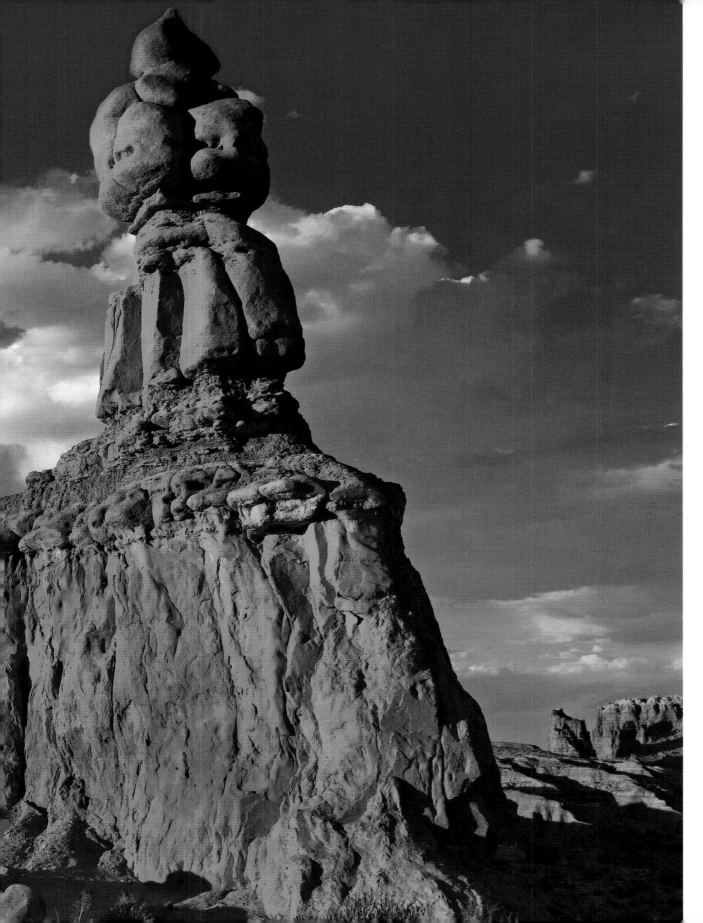

Goblin Valley State Park is home to odd geological formations that give it an extraterrestrial atmosphere. The film *Galaxy Quest* was shot in this other-worldly landscape.

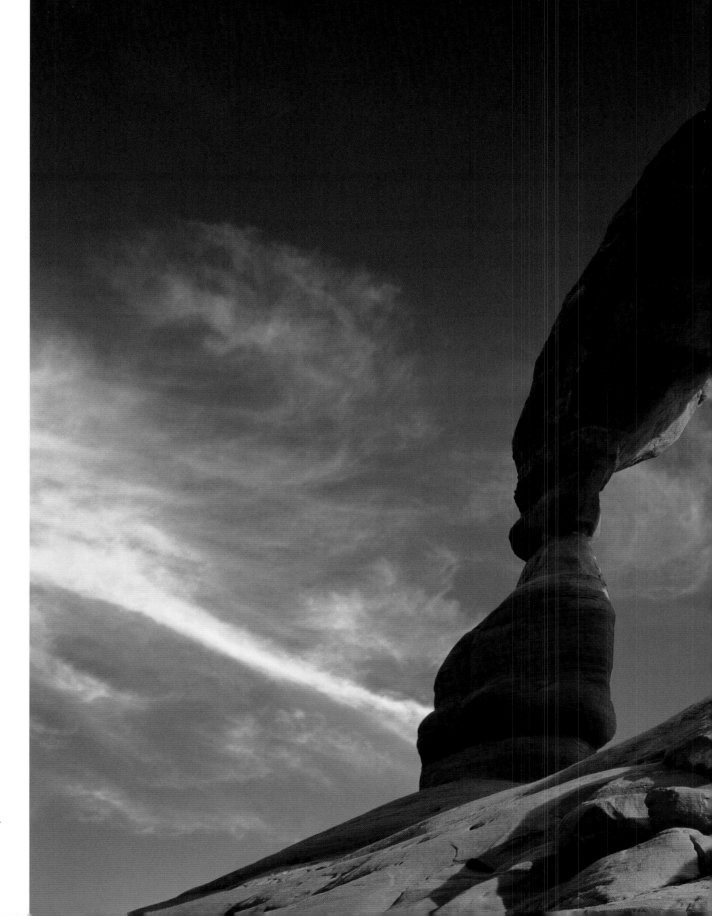

Located in Arches National Park, Utah's most famous landmark—Delicate Arch—is one of the state's most photographed destinations.

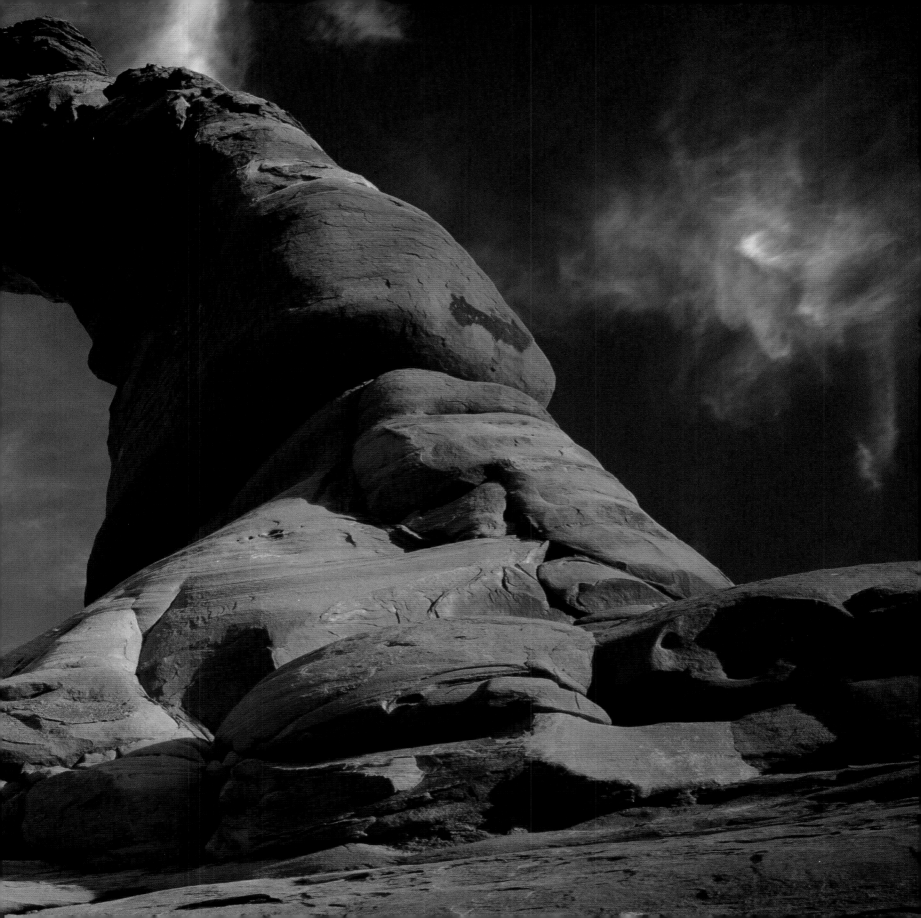

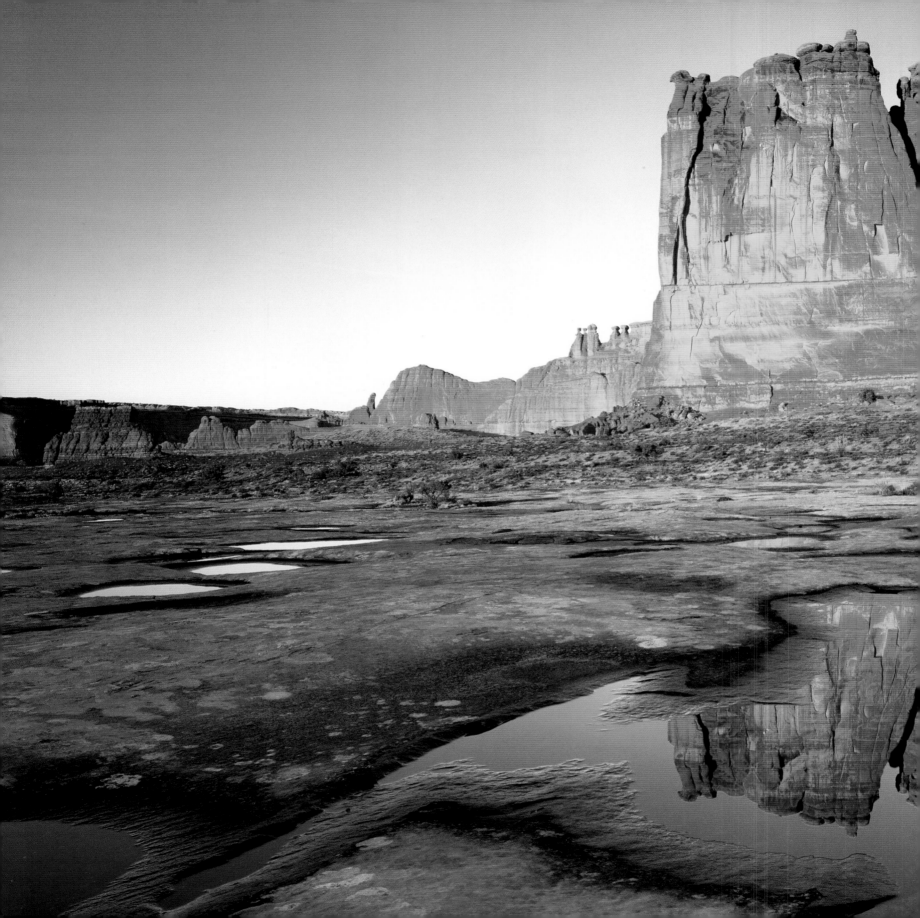

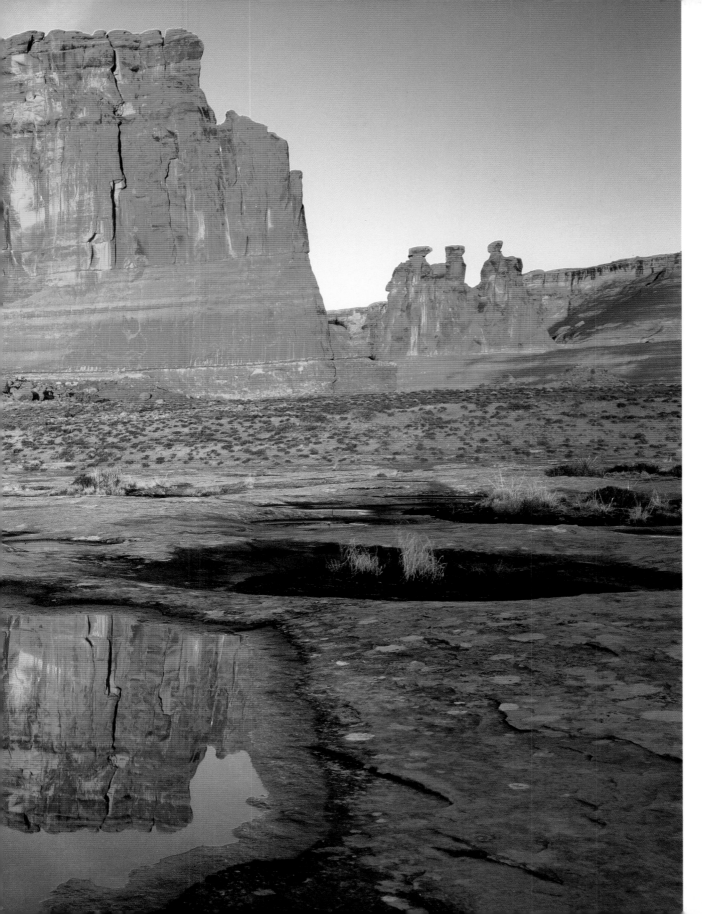

Bizarre rock formations—pinnacles, spires, fins, and arches—populate the striking red desert of the 73,000-acre Arches National Park.

OVERLEAF
Arches National Park contains more than 2,000 sandstone arches. Visitors can drive through the park on a 40-mile stretch of paved road to visit the startling multi-hued rock formations.

51

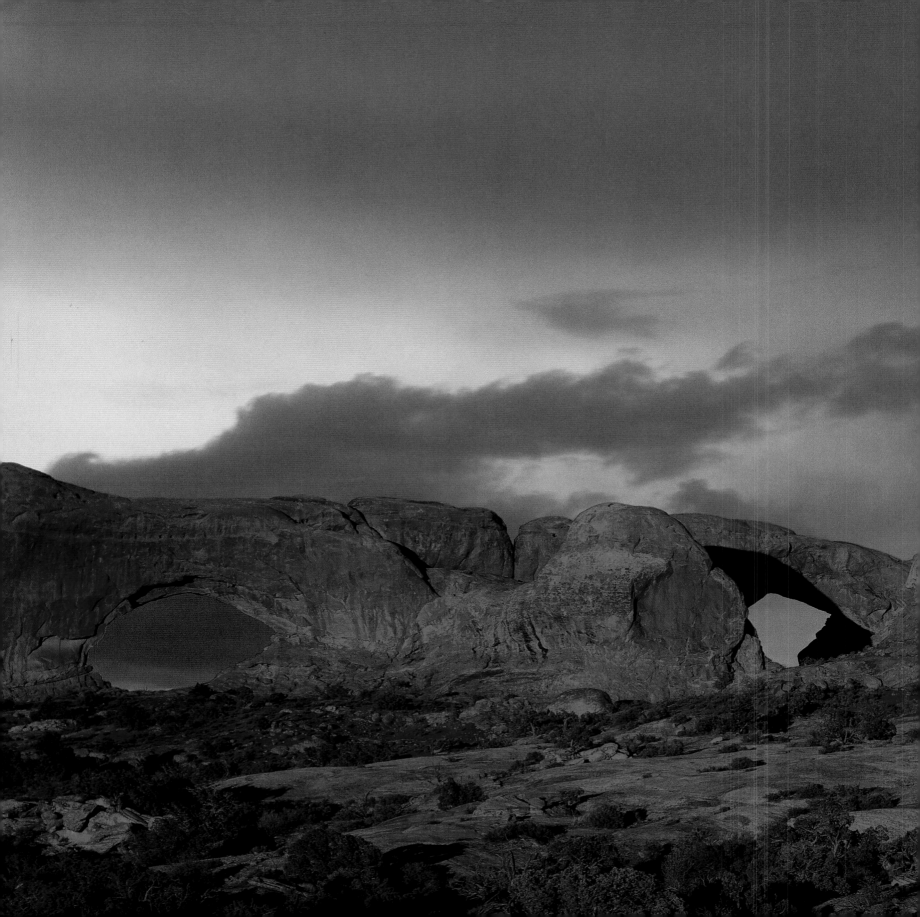

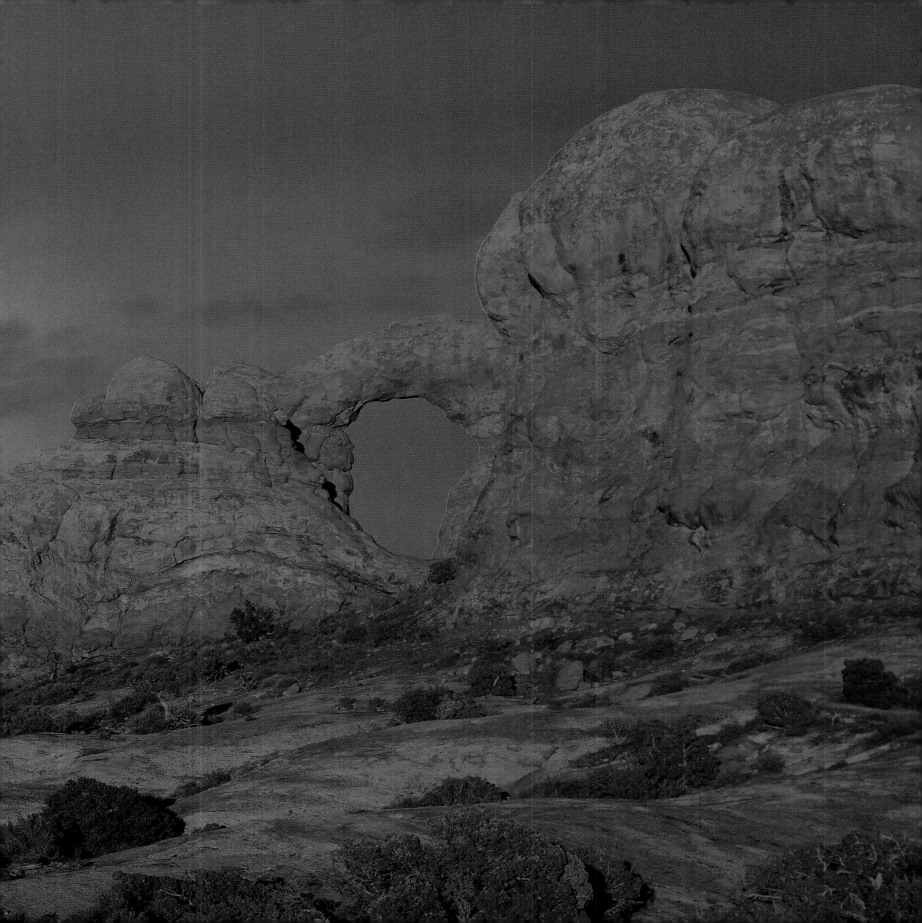

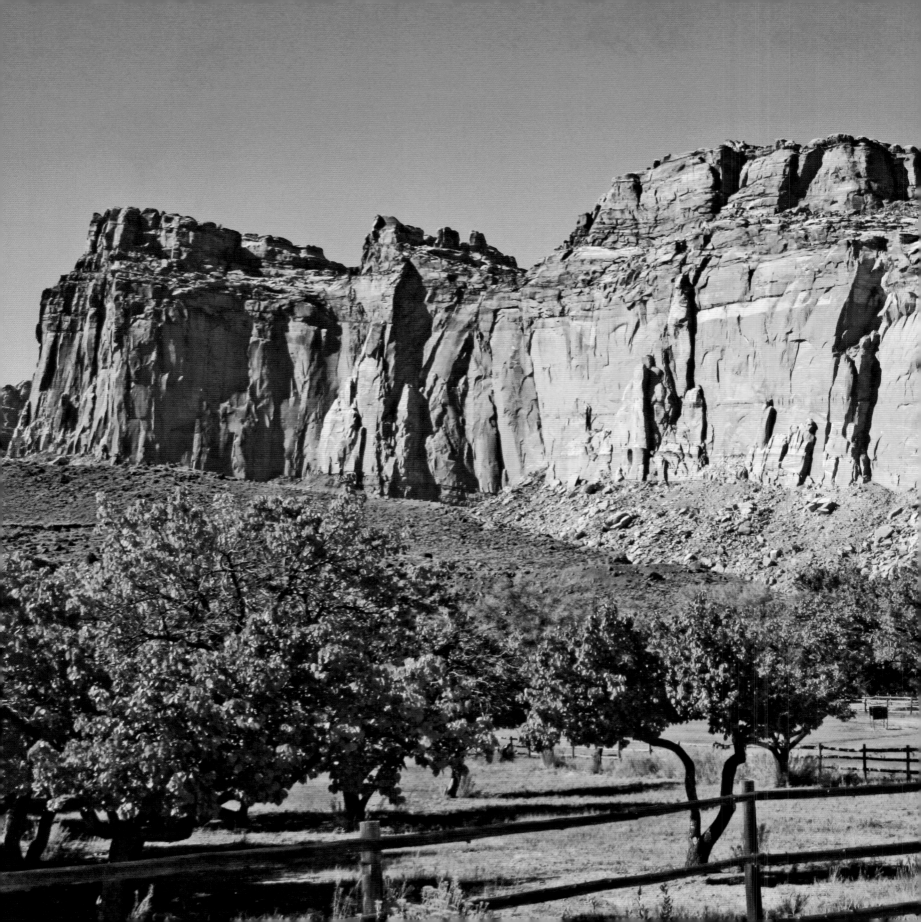

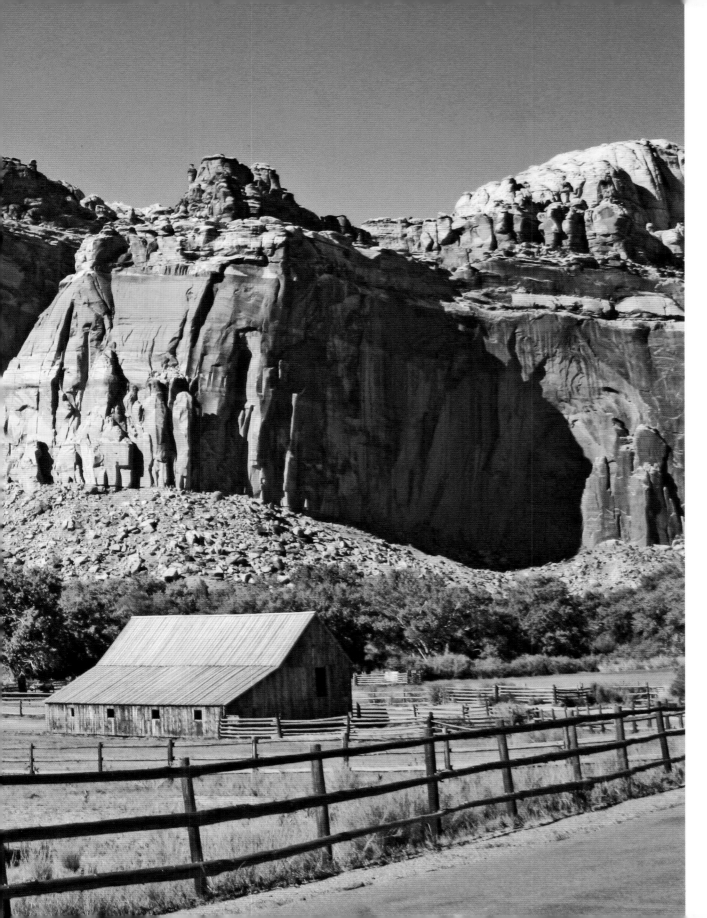

The Fruit Valley, a desert oasis filled with fruit trees, is located in Capitol Reef National Park. Its orchards and the Gifford Farm—remnants of the area's pioneer days—have been preserved to teach visitors about the homesteader's way of life.

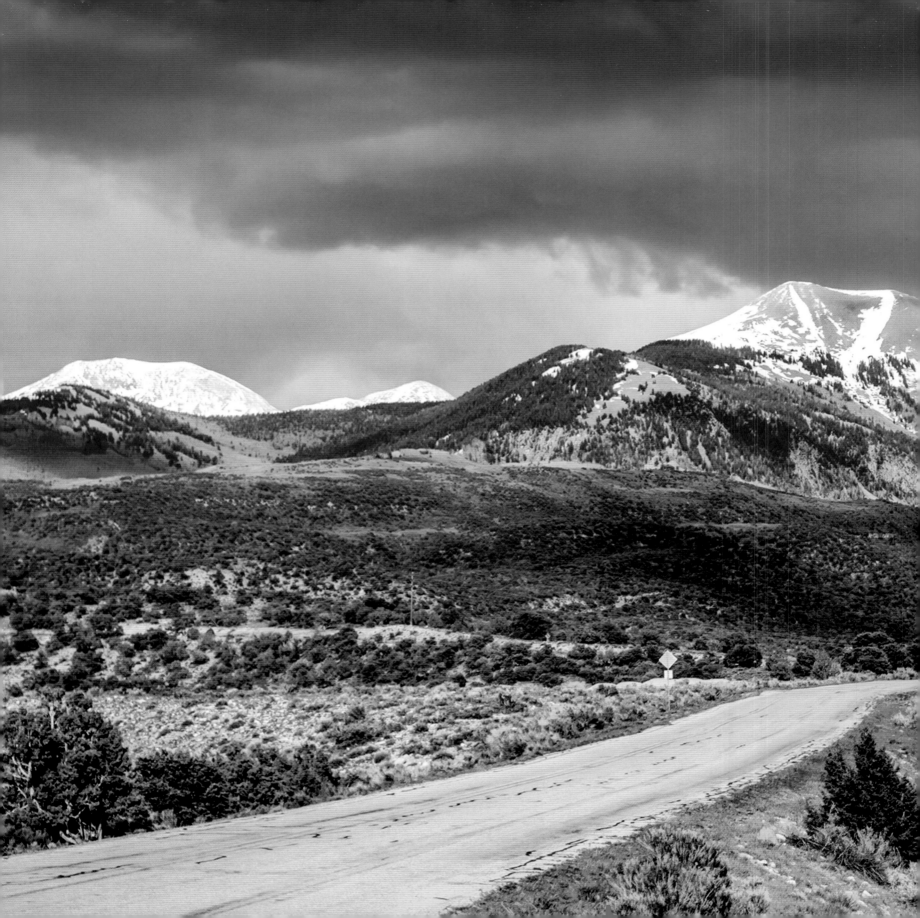

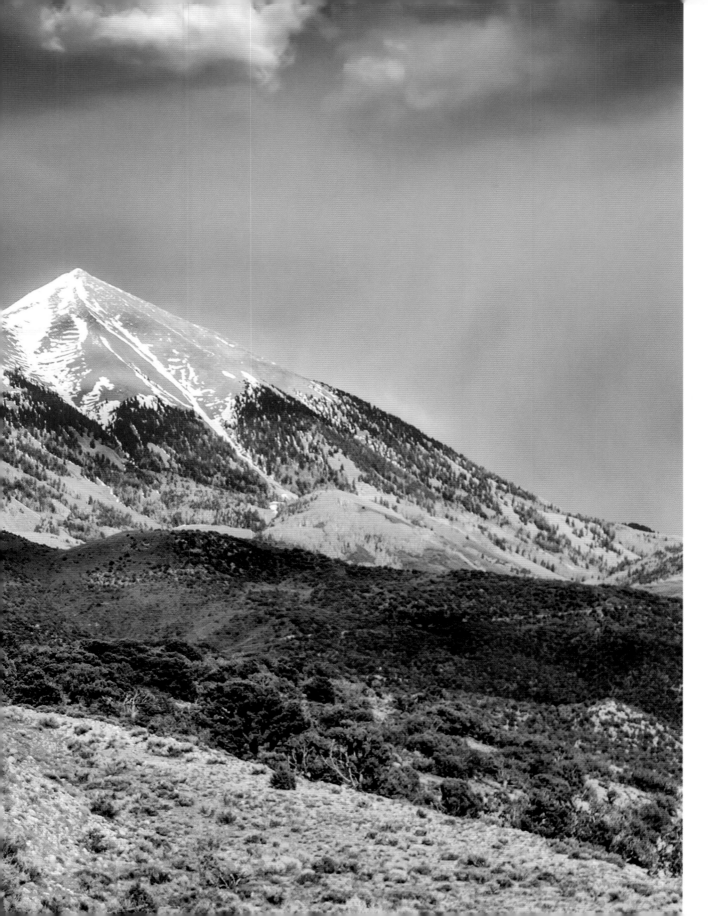

Set in the Manti-La Sal National Forest, the La Sal Mountains—Utah's second highest range—have more than six snow-capped peaks that reach over 12,000 feet.

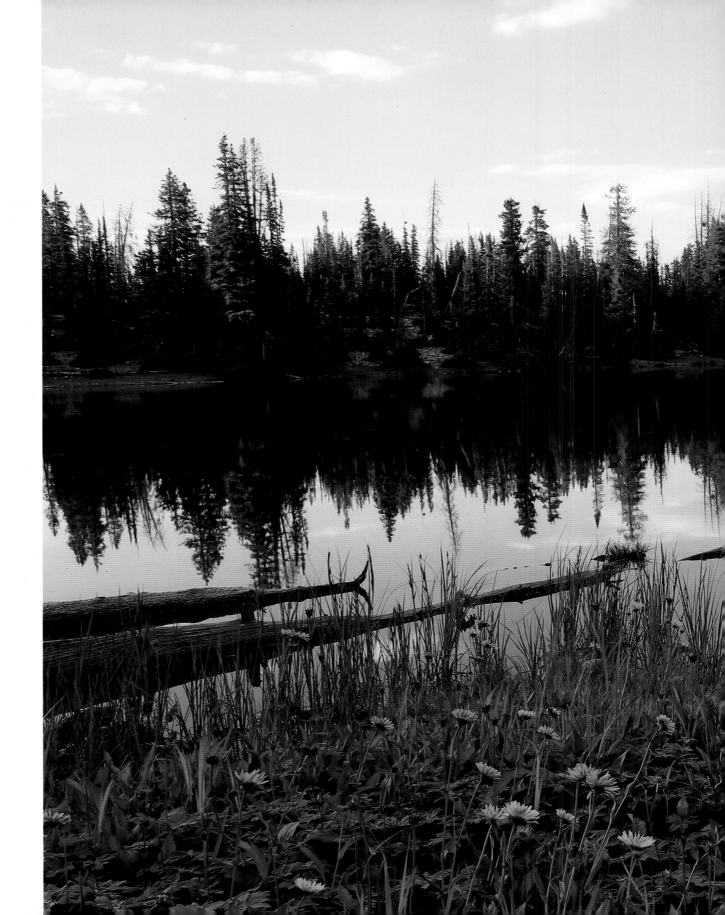

The highest range in Utah—the Uinta Range—reaches heights of more than 13,500 feet. It's the only major mountain range in the continental United States that runs east to west.

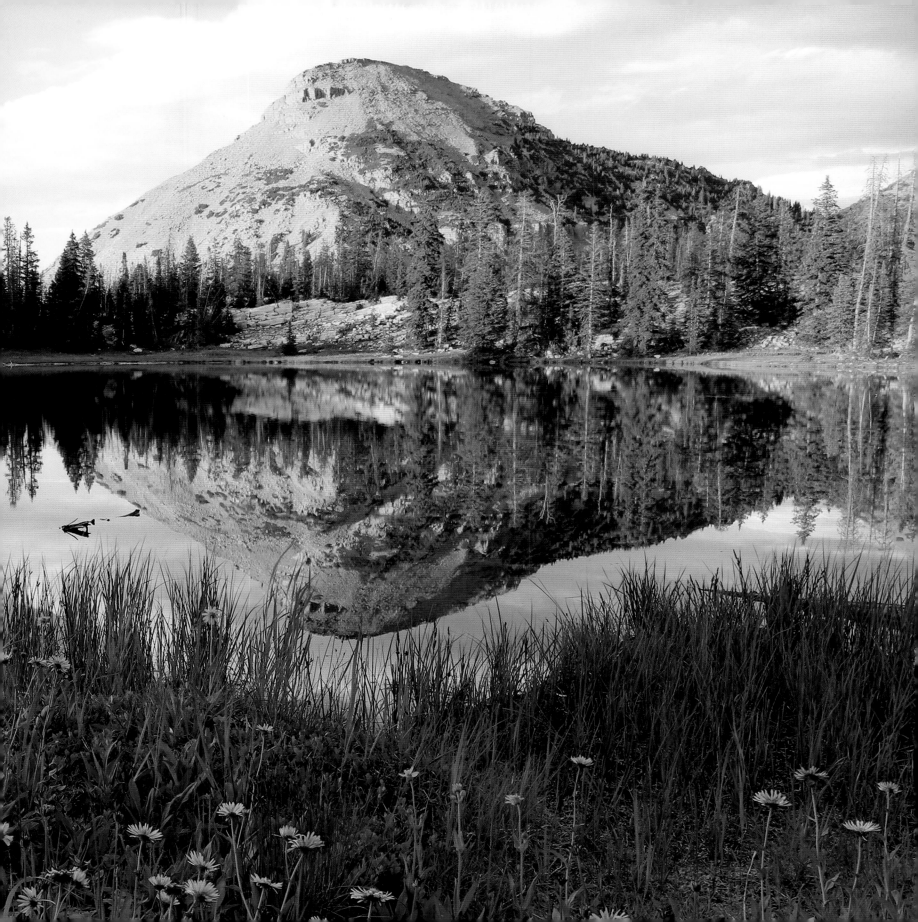

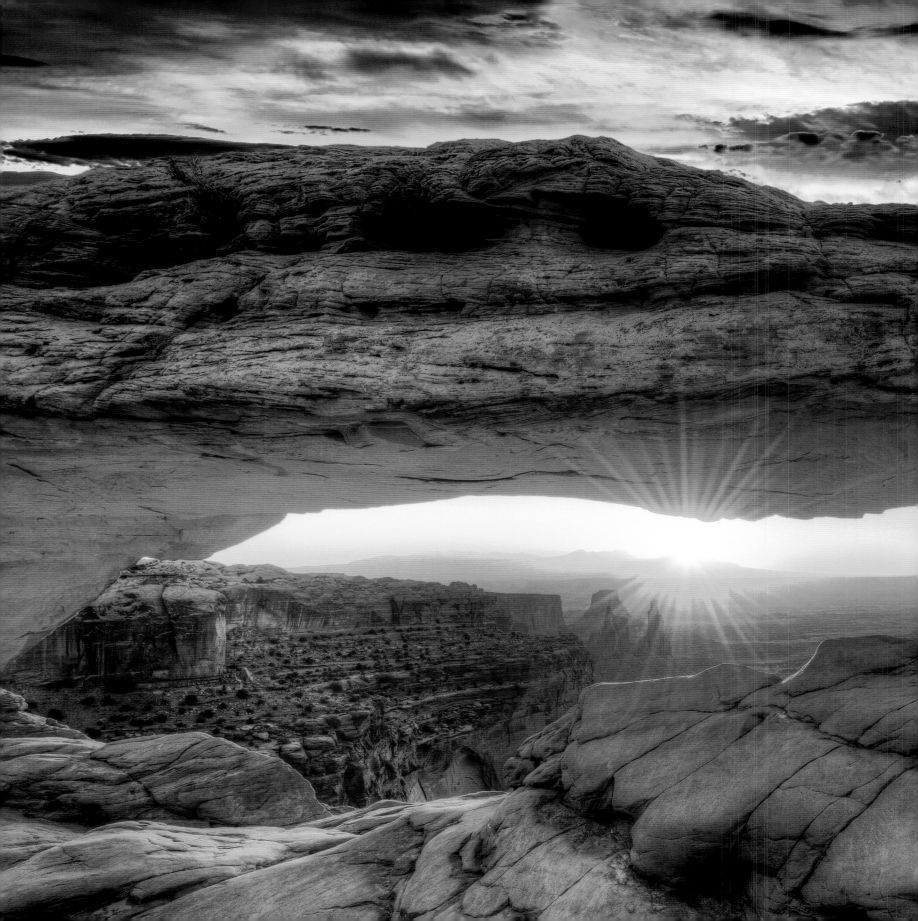

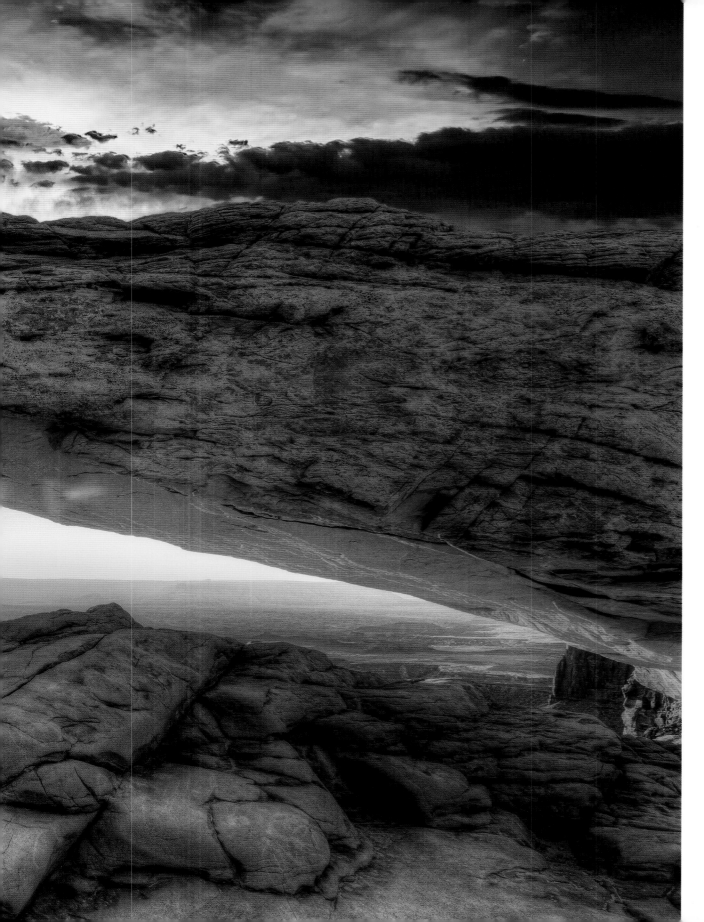

More than
375,000 people
visit Canyonlands
National Park each
year to witness its
dramatic landscapes.

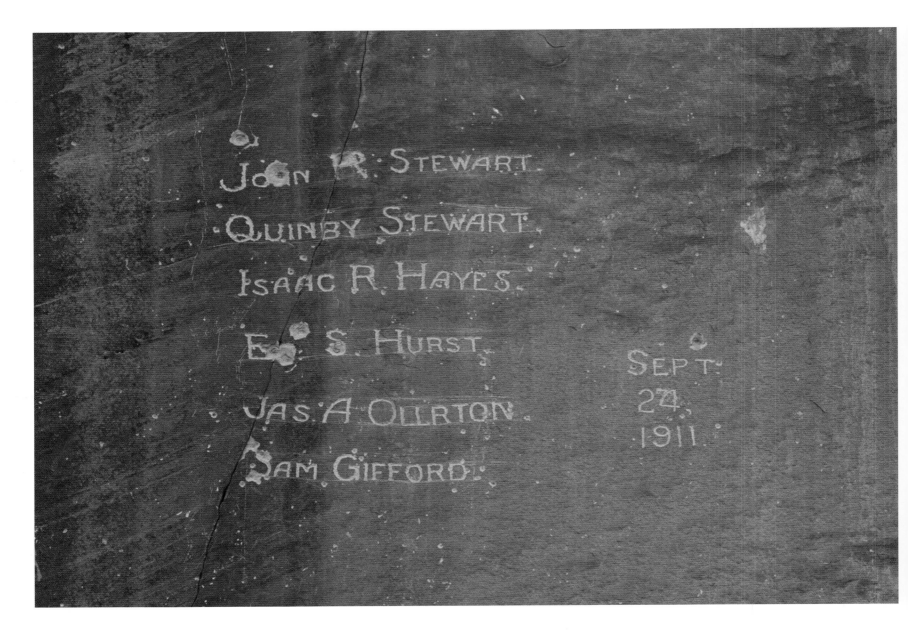

Early pioneer names are scratched into the cliff face of Capitol Reef National Park. Named after the dome-shaped rocks resembling the U.S. Capitol, the park is filled with unique sandstone formations and features a 100-mile-long bulge in the earth's surface.

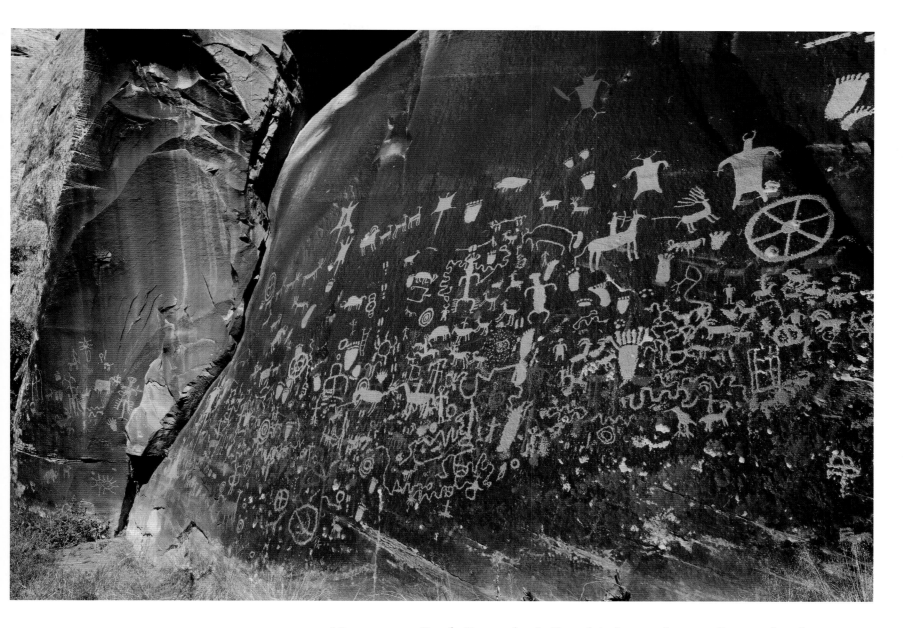

Newspaper Rock Petroglyph Panel is located near Canyonlands Needles District. This historic monument depicts images by the Anasazi, Fremont, and Navajo Native American tribes dating back to 2,000 years ago.

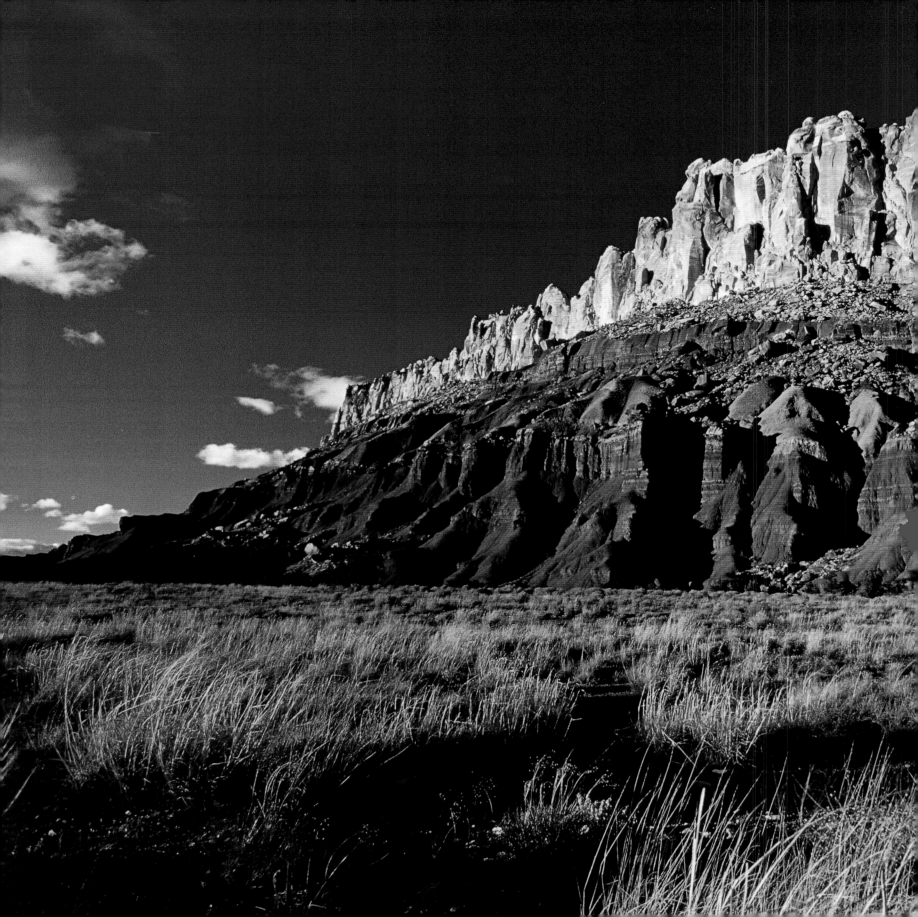

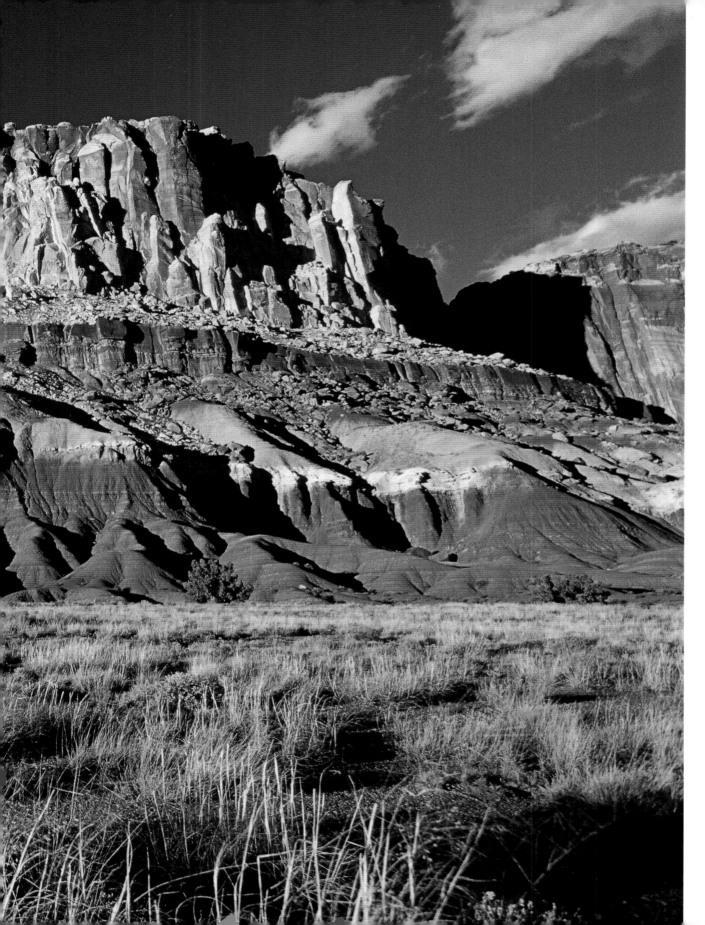

Every year, more than half a million visitors a come to see the natural wonders of Capitol Reef's 241,904 acres.

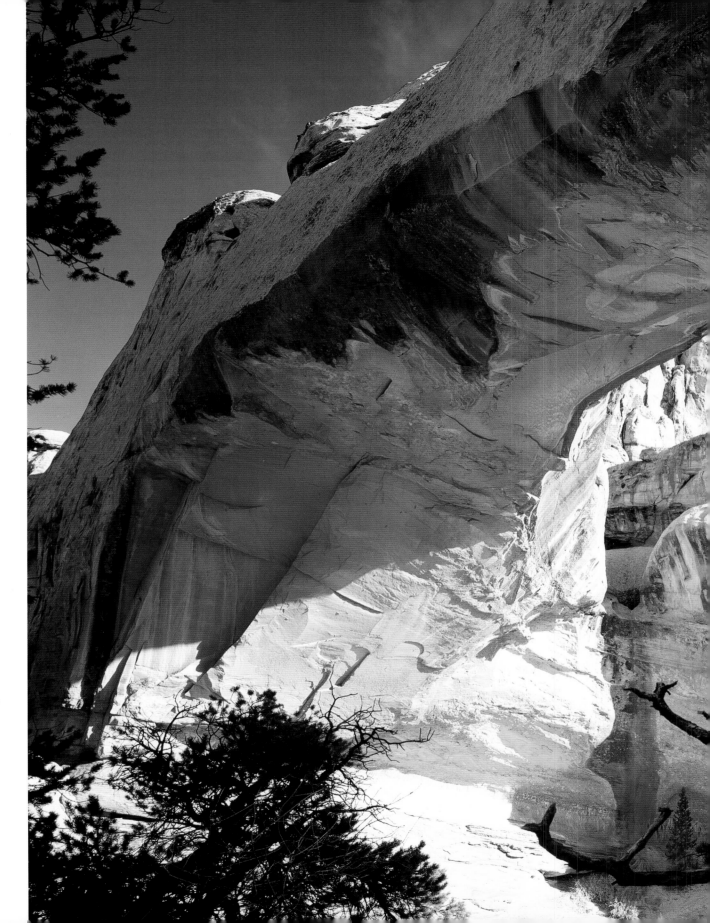

One of the highlights of Capitol Reef National Park, the Hickman Bridge rises 125 feet above the ground and spans 130 feet.

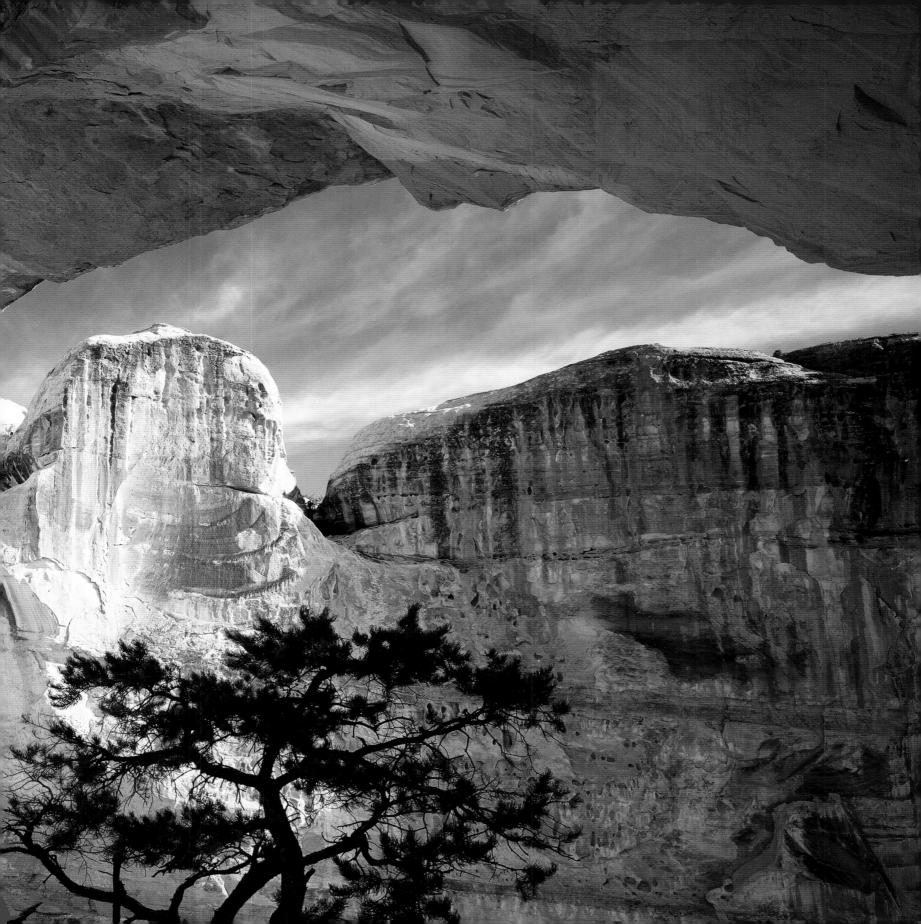

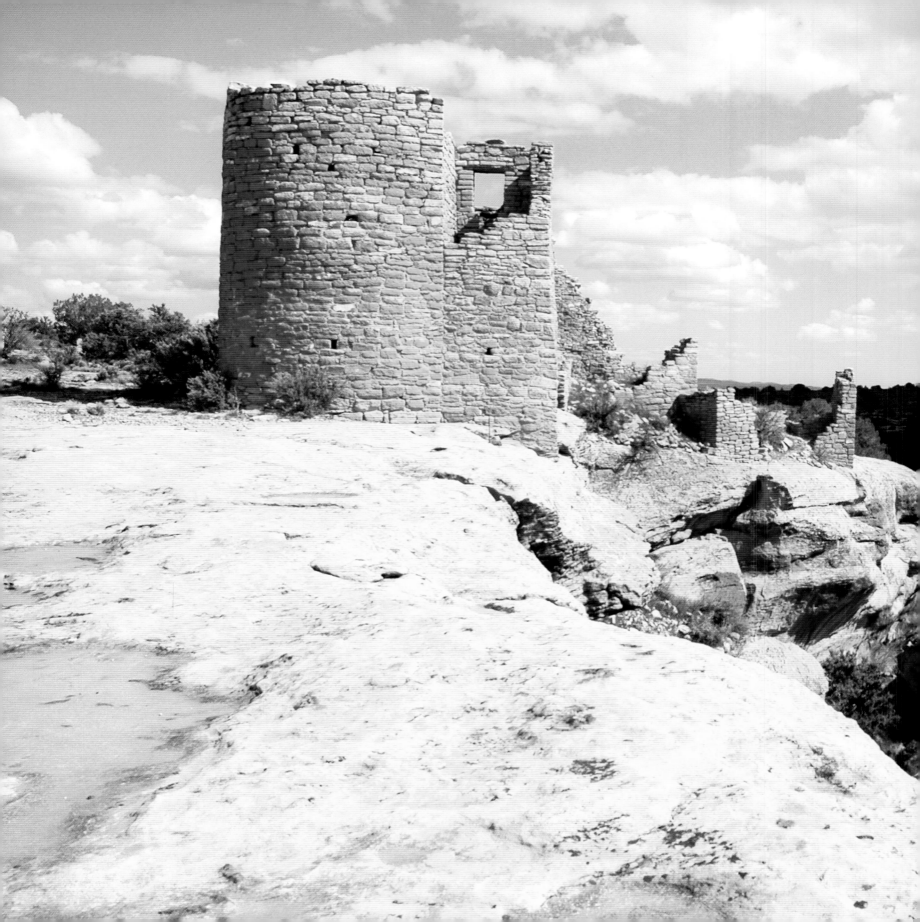

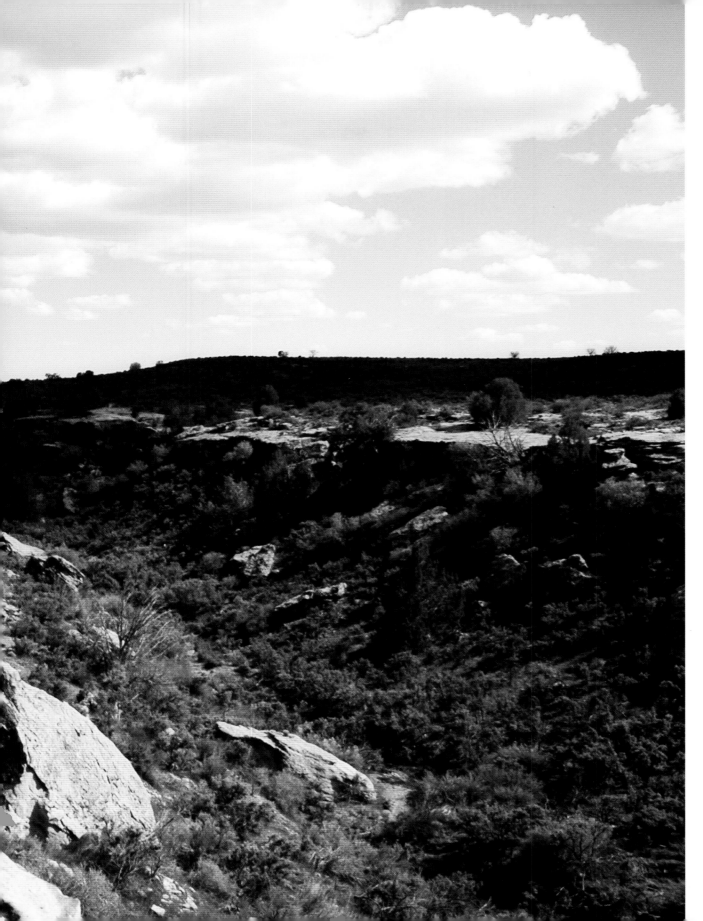

Hovenweep National
Monument contains
six prehistoric
Pueblo villages.
These villages con-
tain multi-level
buildings, balanced
on boulders and
canyon rims, that
demonstrate the
architectural mastery
of their builders.

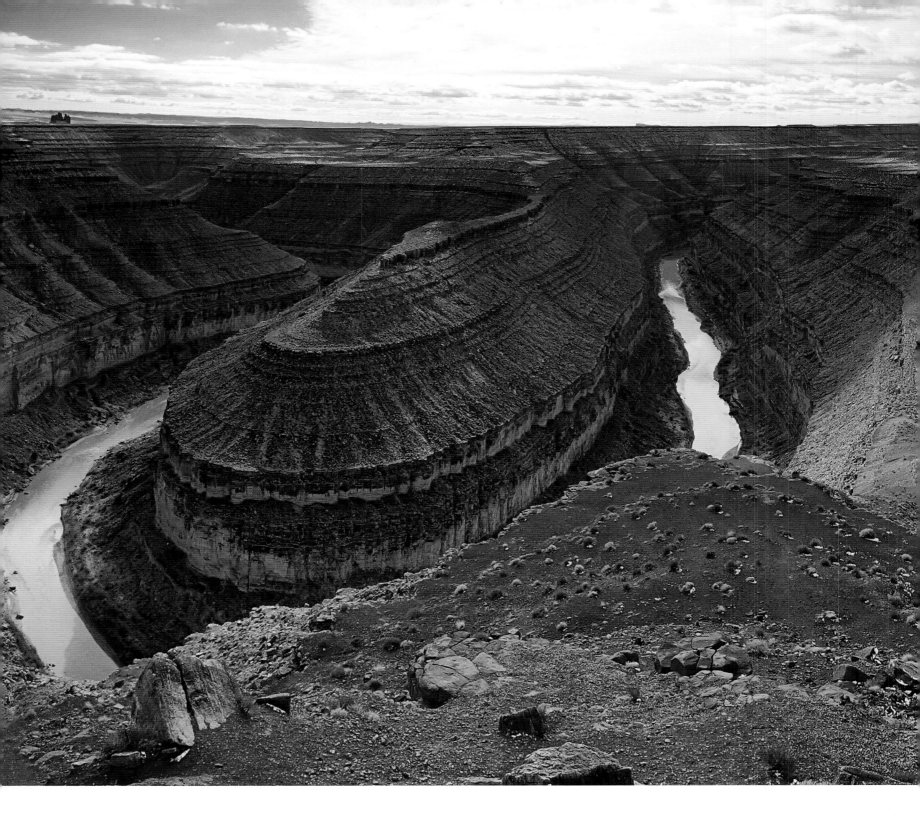

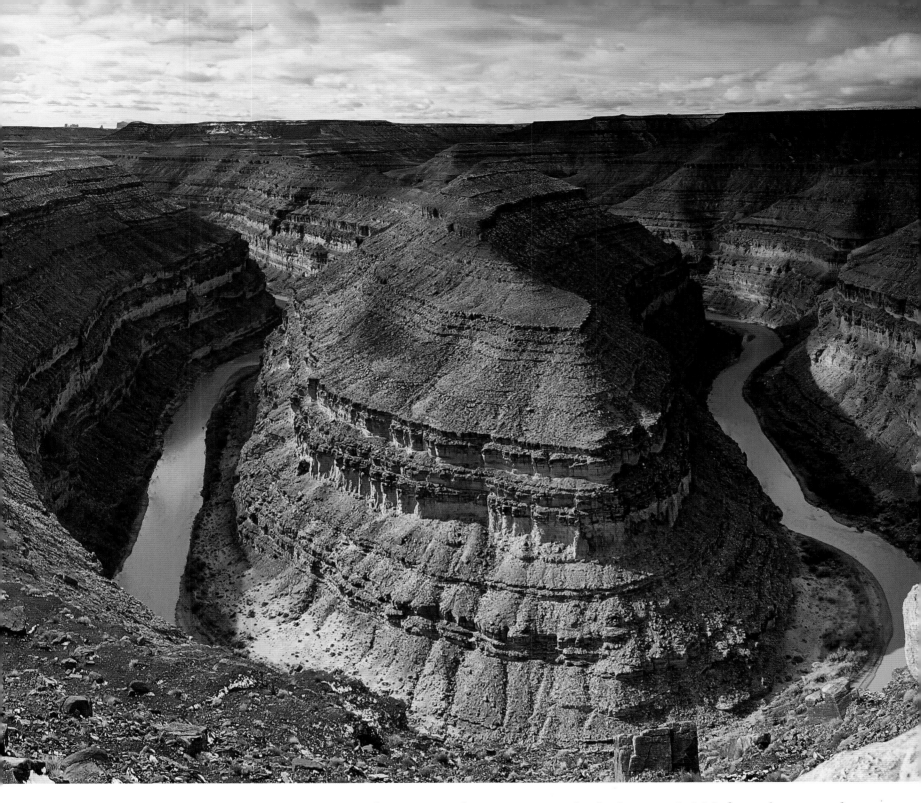

At Goosenecks State Park, visitors can look down a 1,000-foot chasm to the meandering San Juan River. Although the river weaves back and forth for five miles, it progresses only one mile.

The 11th largest state in the U.S., Utah occupies 84,900 square miles. One of the Four Corner states, it borders Idaho, Wyoming, Colorado, New Mexico, Arizona, and Nevada.

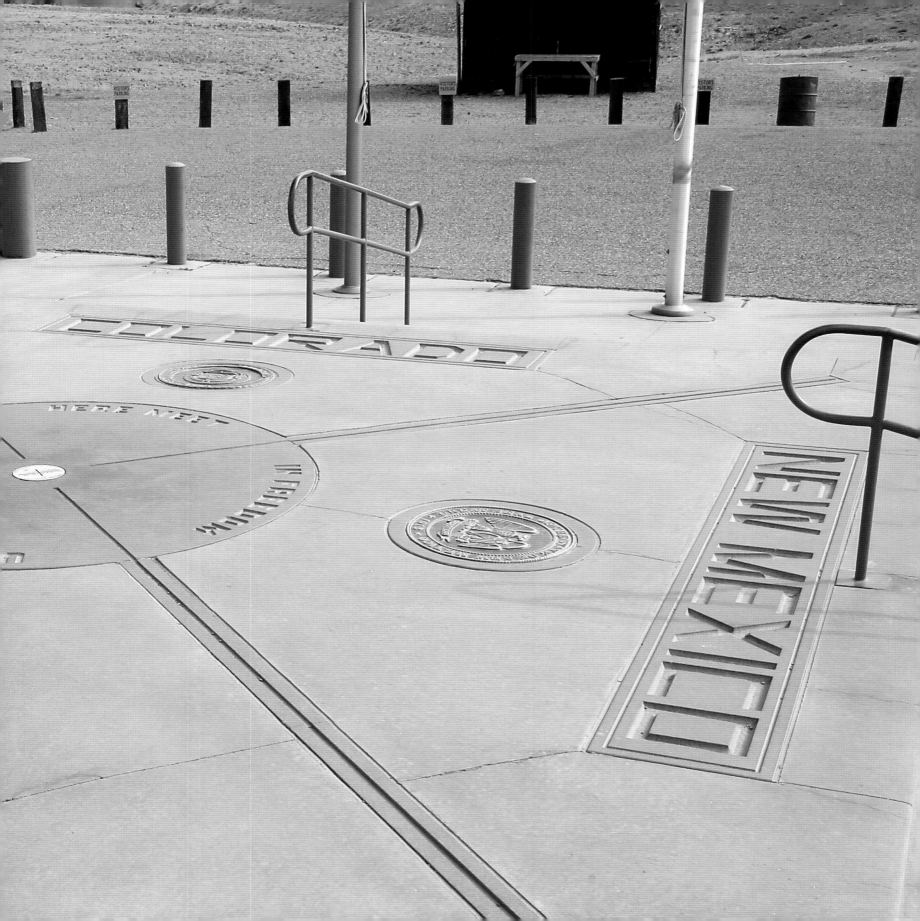

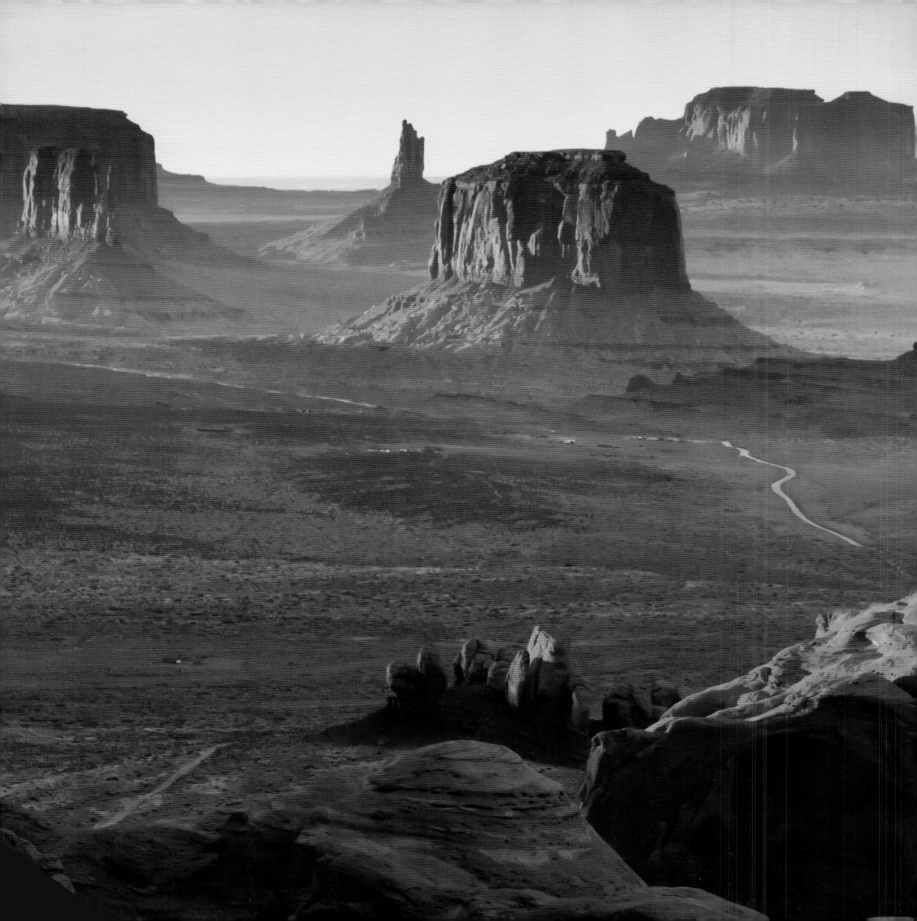

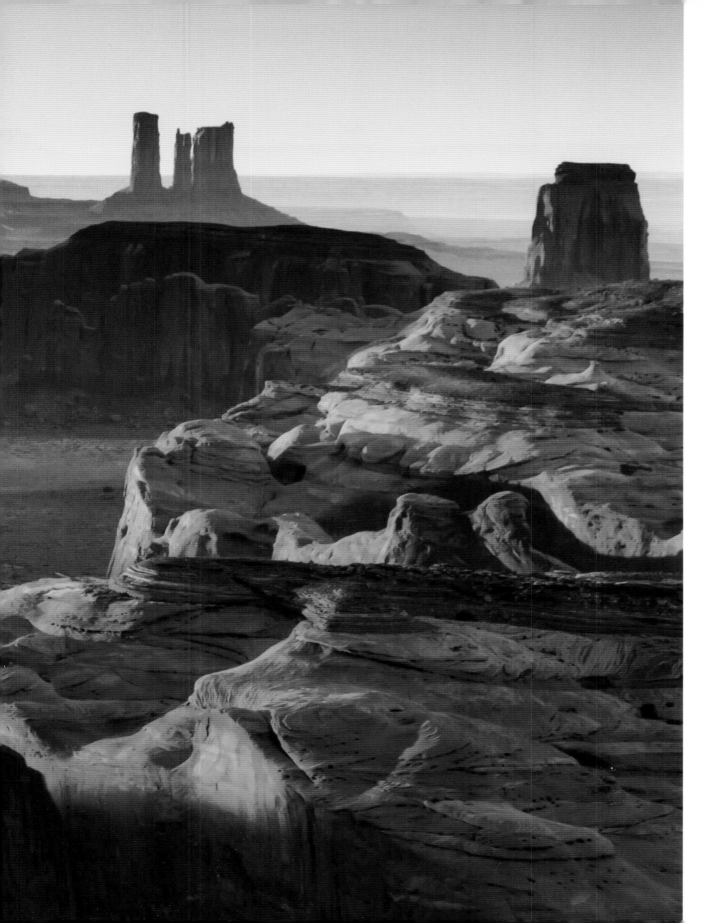

Free-standing rock formations rise up dramatically from the desert floor of Monument Valley. Up to 1,000 feet high, these mesas and buttes once formed part of a massive sandstone layer that slowly eroded over millions of years.

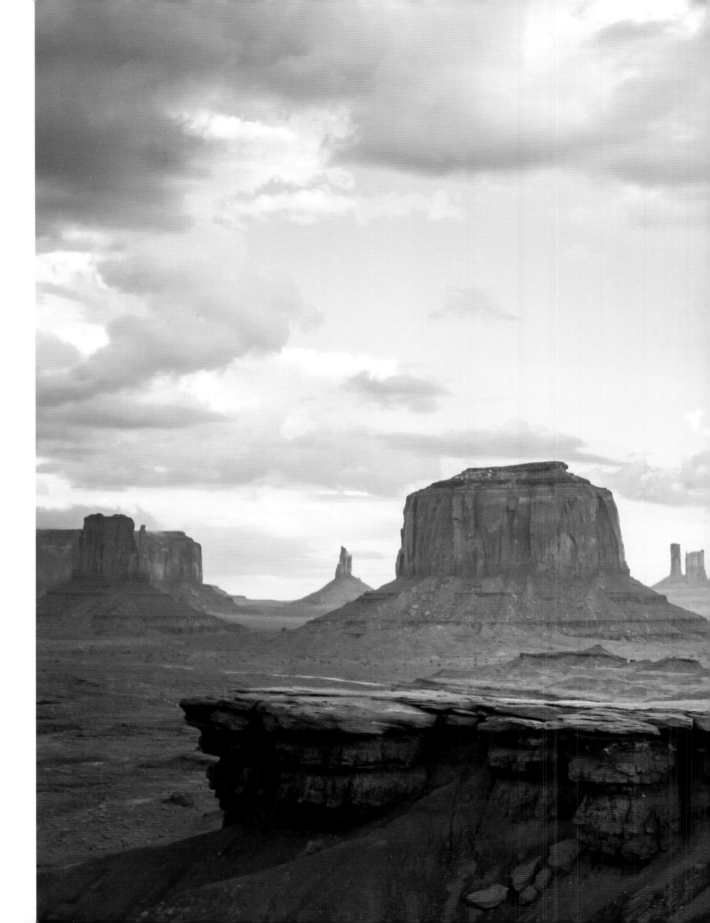

Monument Valley Park belongs to the Navajo Nation in southeastern Utah. Rock formations soar to heights of 400 to 1,000 feet.

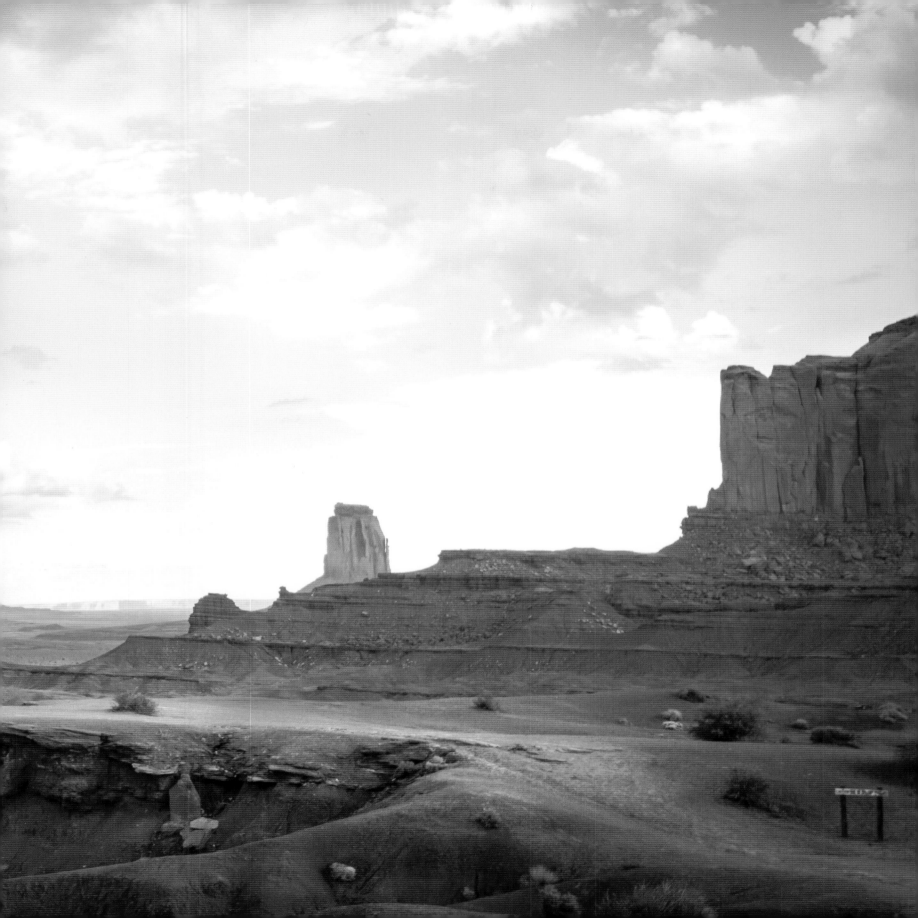

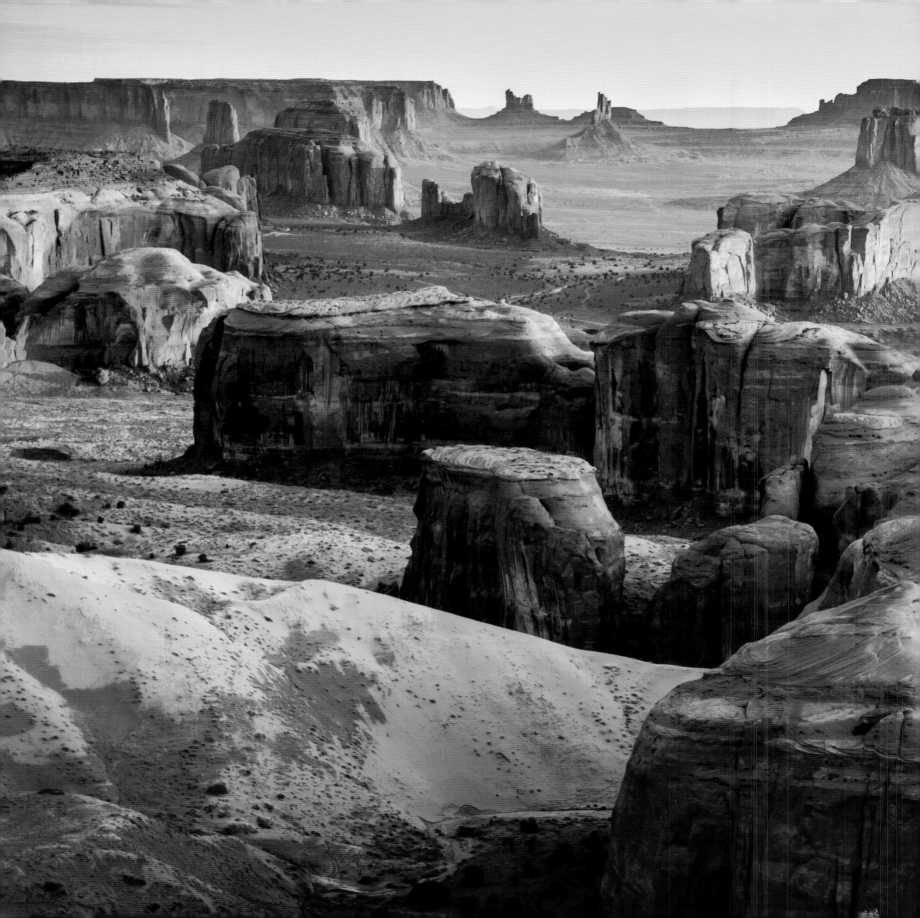

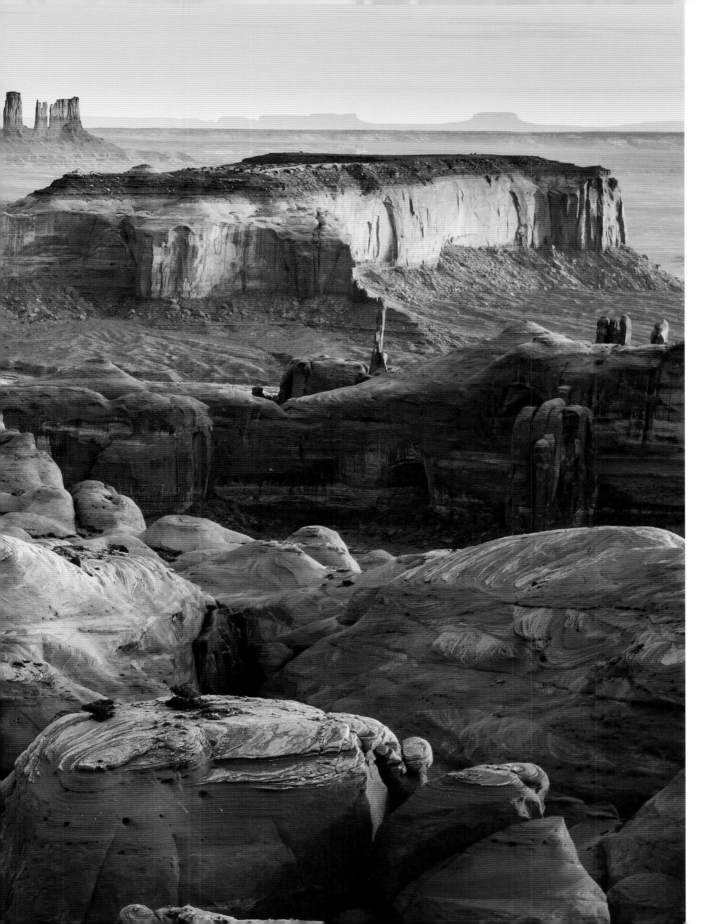

Many western
movies were filmed
in Monument Valley.
The dramatic, rugged
landscapes provide
the perfect Wild
West settings.

79

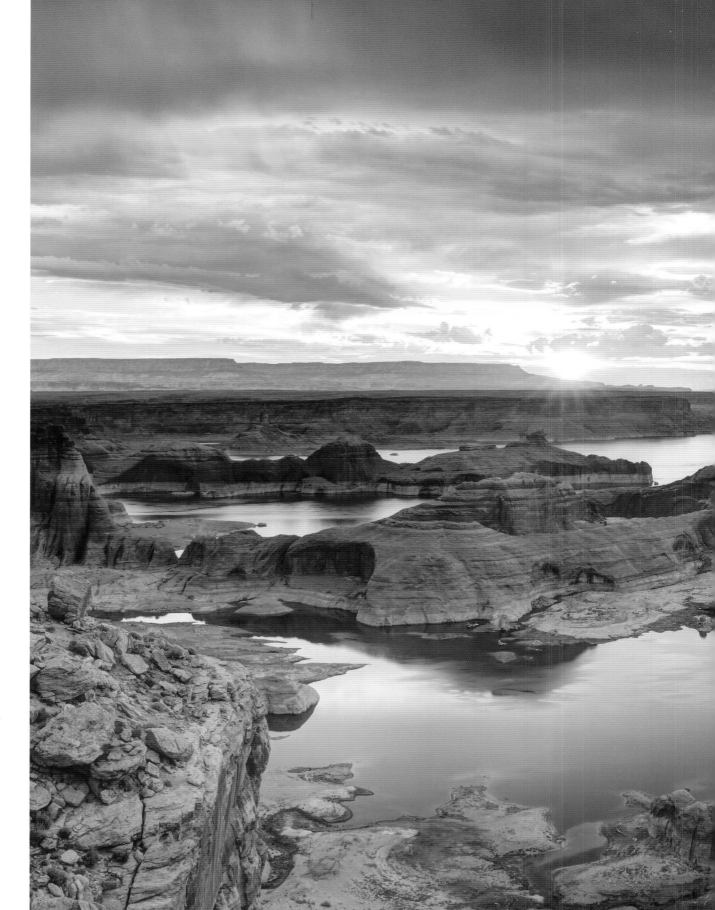

Often called "America's Natural Playground," Lake Powell is the second largest reservoir in North America. With almost 2,000 miles of shoreline, it's perfect for house-boating, fishing, and swimming.

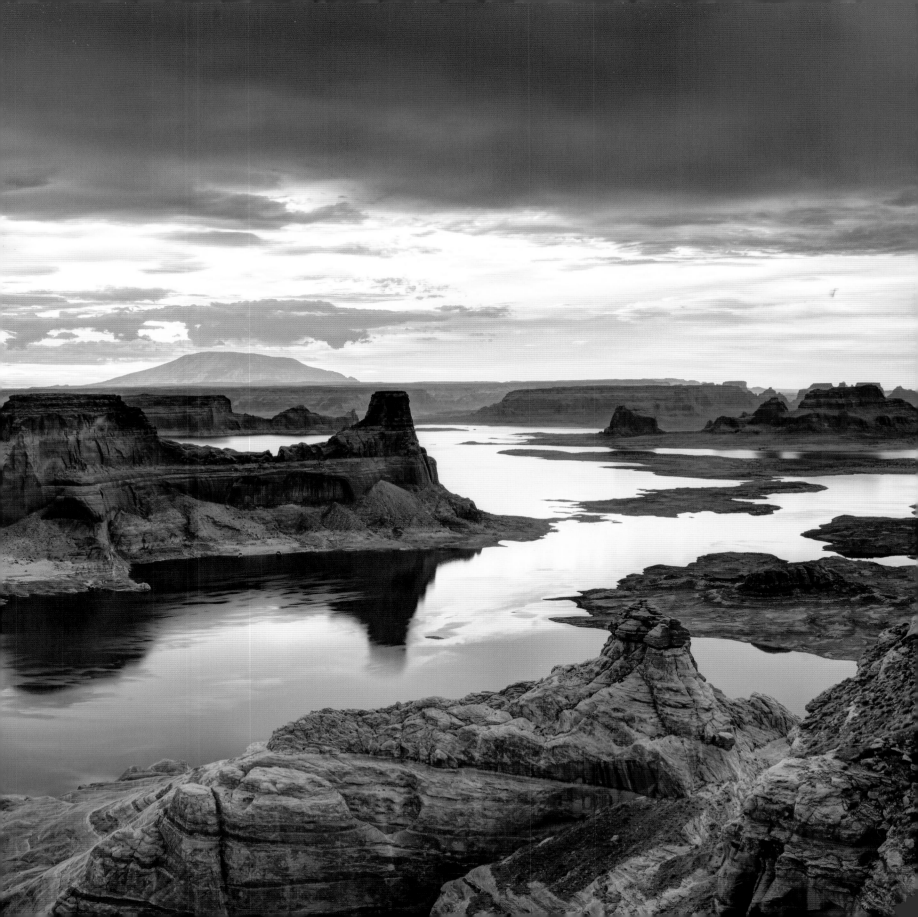

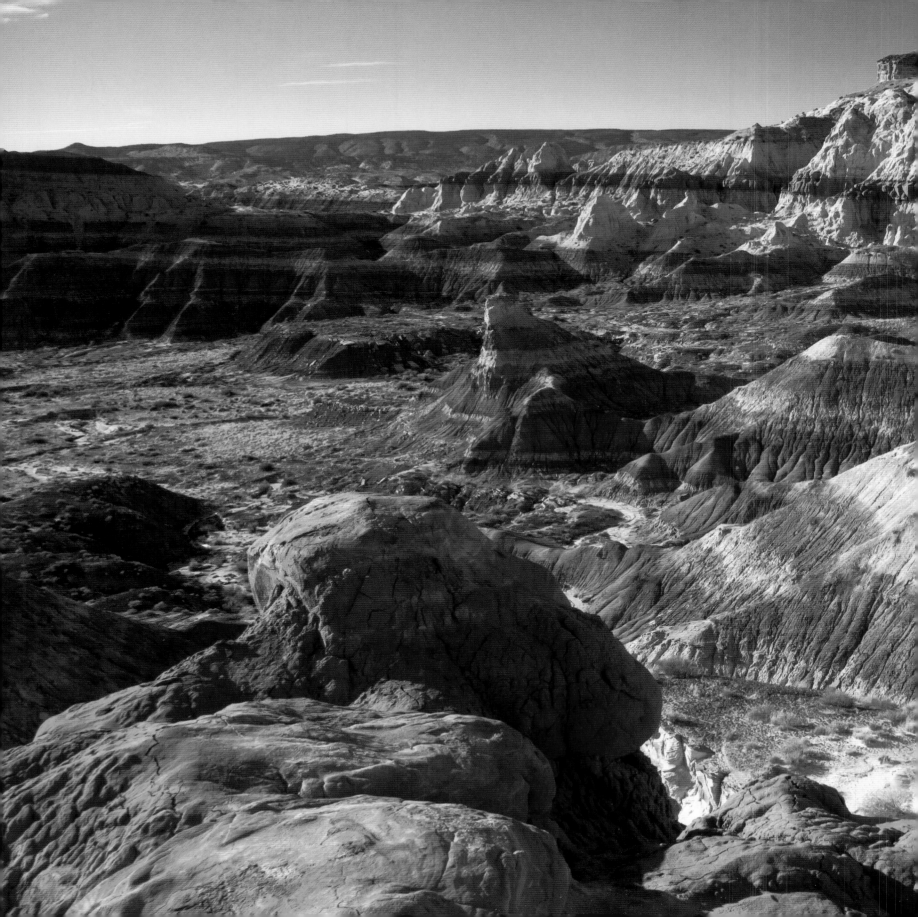

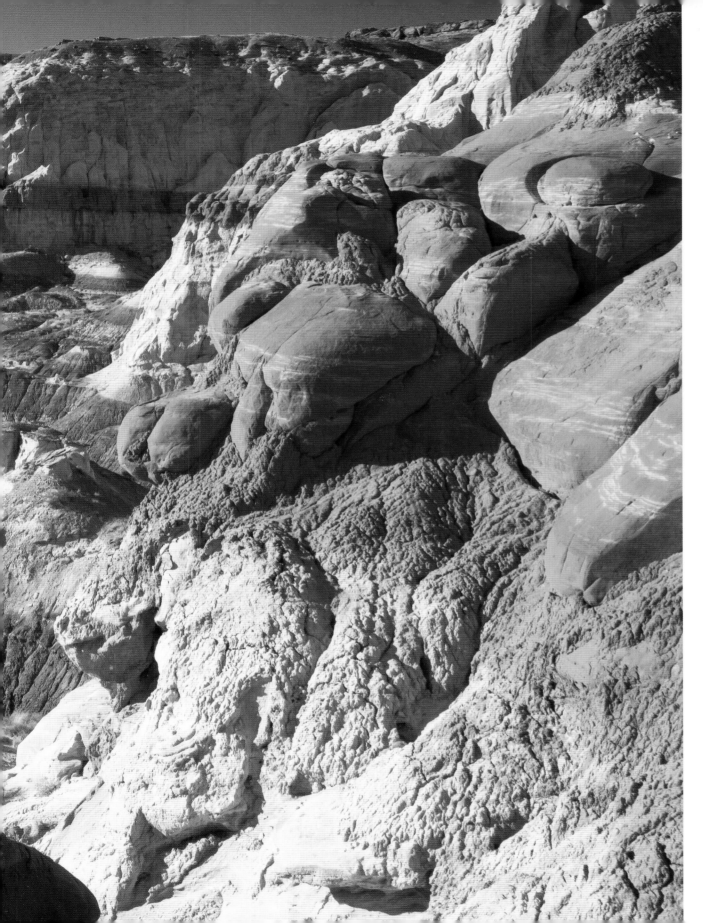

Named for the
natural staircase that
climbs 5,000 feet
to the rim of Bryce
Canyon, Grand
Staircase-Escalante
National Monument
is filled with a variety
of dramatic, multi-
colored cliffs and
canyons.

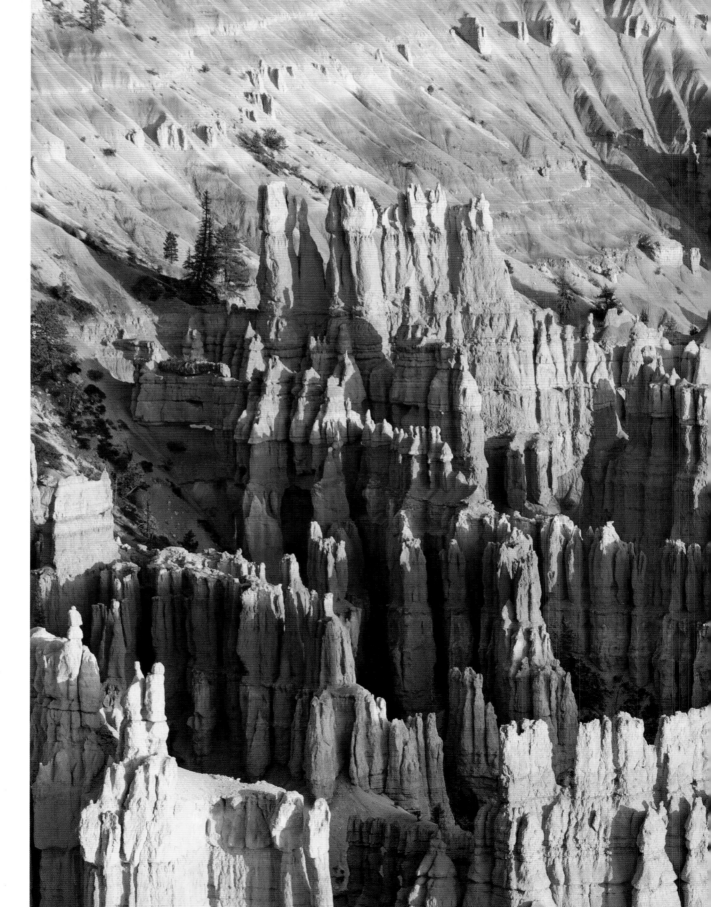

Bryce Canyon, named after Mormon pioneer Ebenezer Bryce, features dramatic horseshoe-shaped amphitheaters fashioned by nature from vibrant, multi-hued rocks.

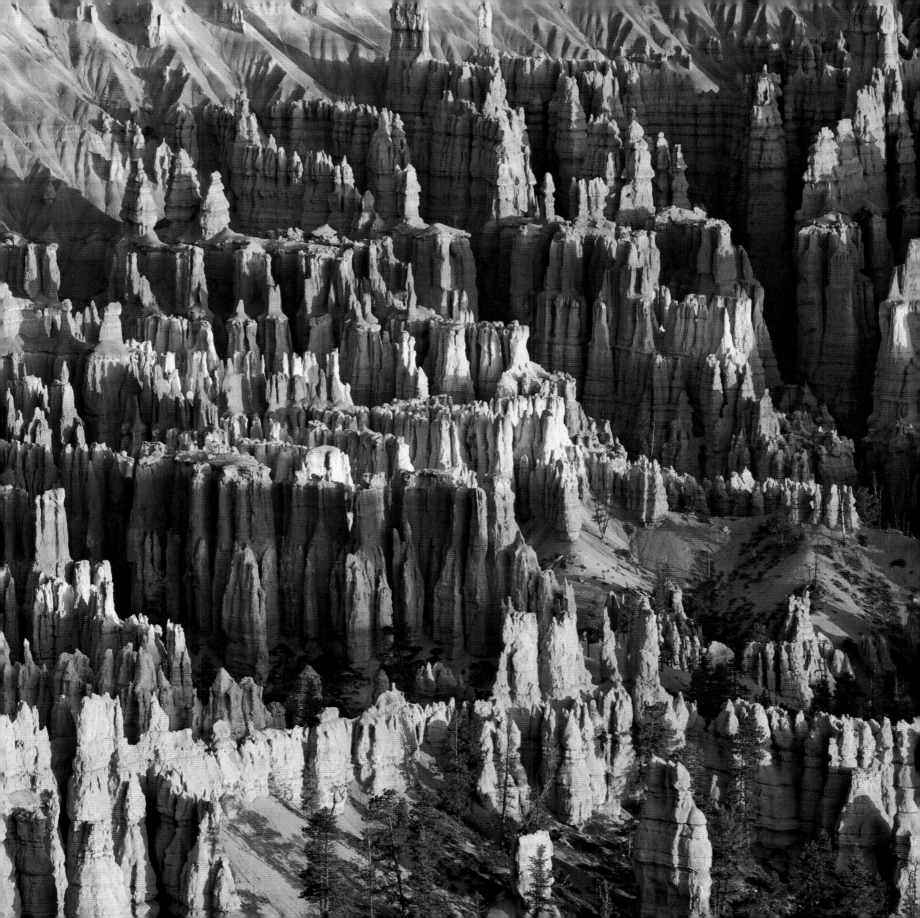

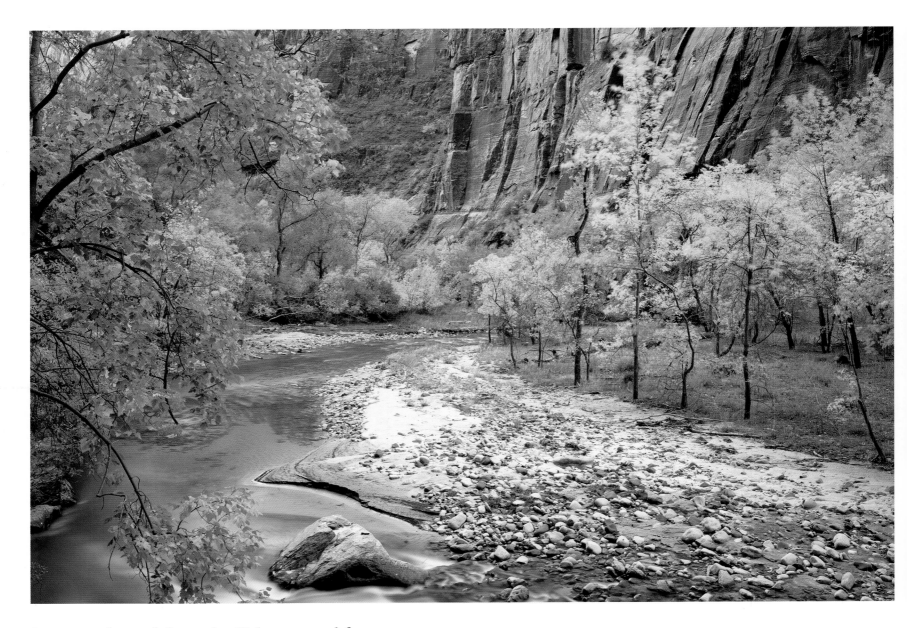

Its name derived from the Hebrew word for sanctuary,
Zion National Park protects more than 225 square miles of land.

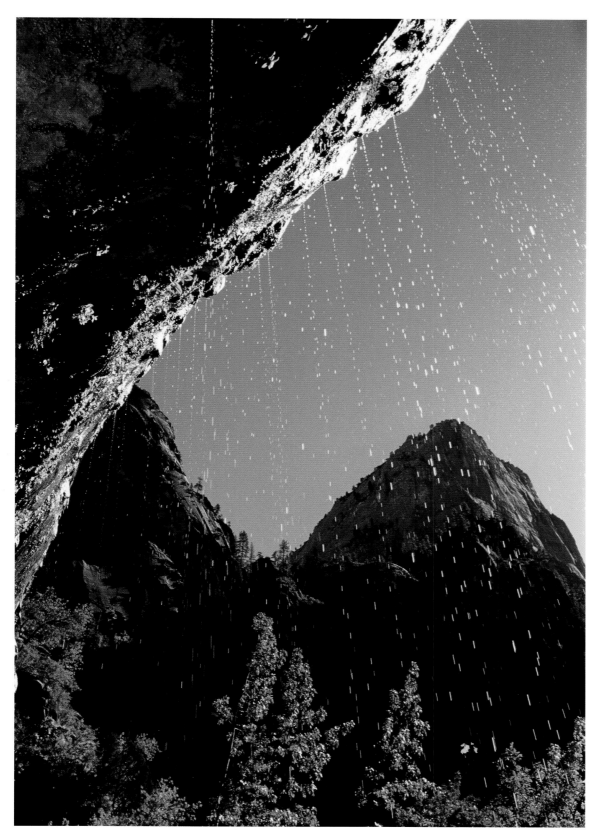

Located at the junction of the Colorado Plateau, Great Basin, and Mojave Desert, Zion National Park features a diverse collection of wildlife, plants, and geographical formations.

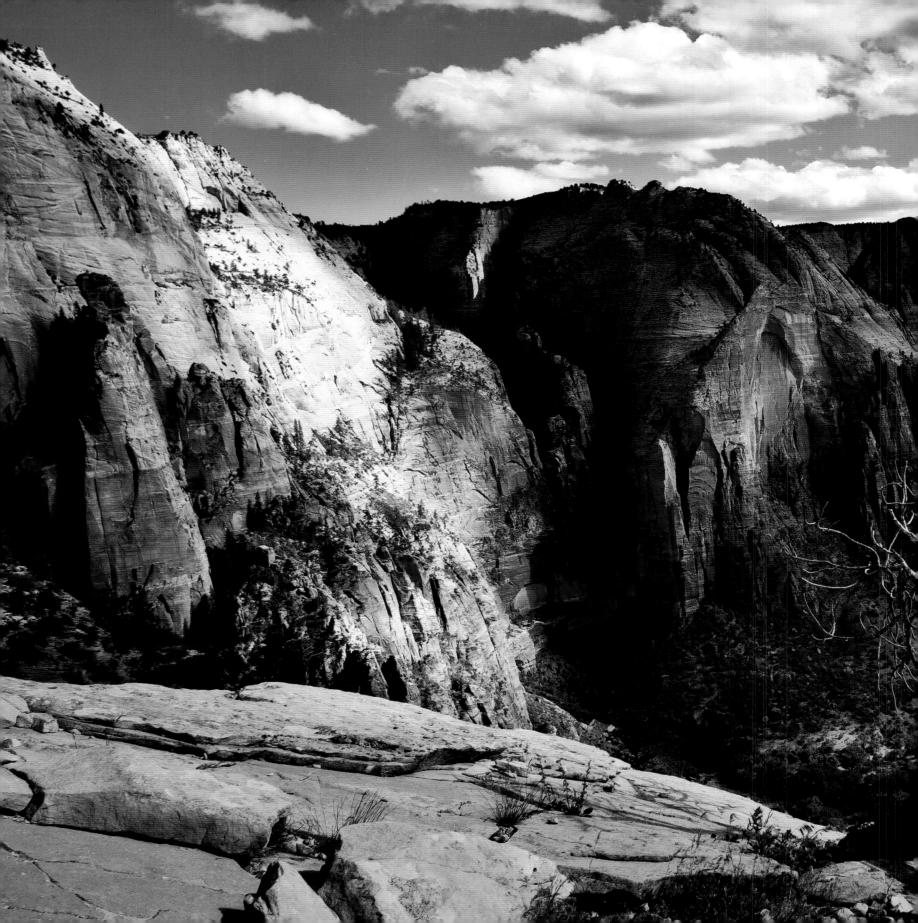

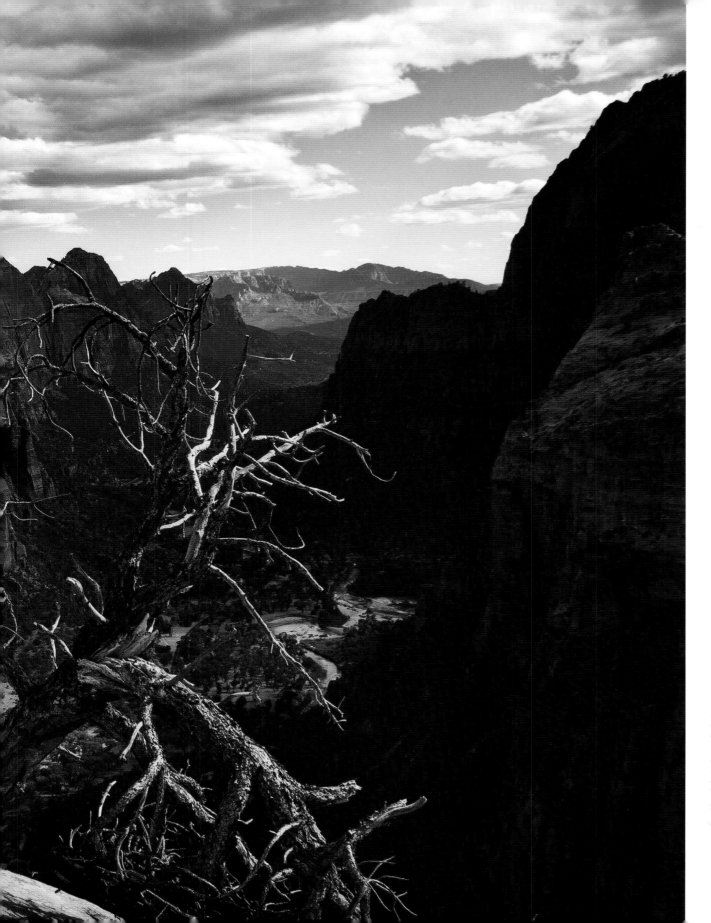

Zion National Park is Utah's oldest national park. Designated in 1919, it attracts almost 3 million visitors a year.

Boasting rock formations over 150 million years old, life zones spanning from desert to woodland, and elevations over 8,000 feet, the Zion National Park is a slice of nature worth visiting. Pictured here is the Temple of Sinawava, a picturesque location found at the end of the 6 mile long road into Zion Canyon.

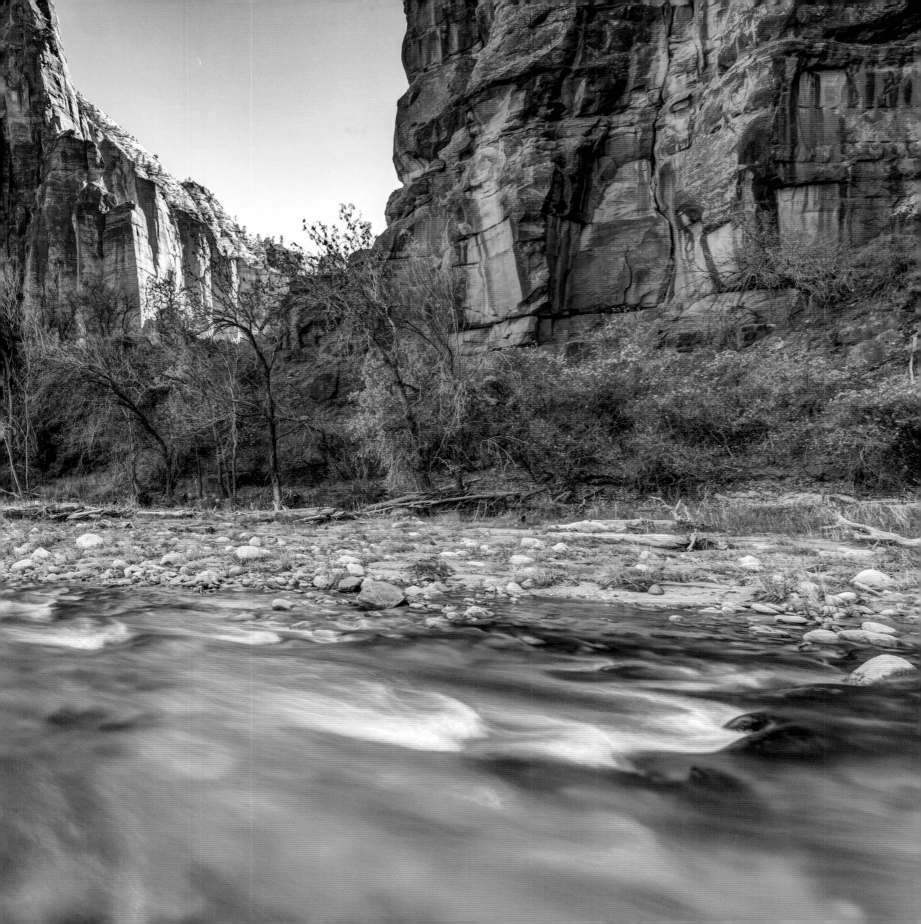

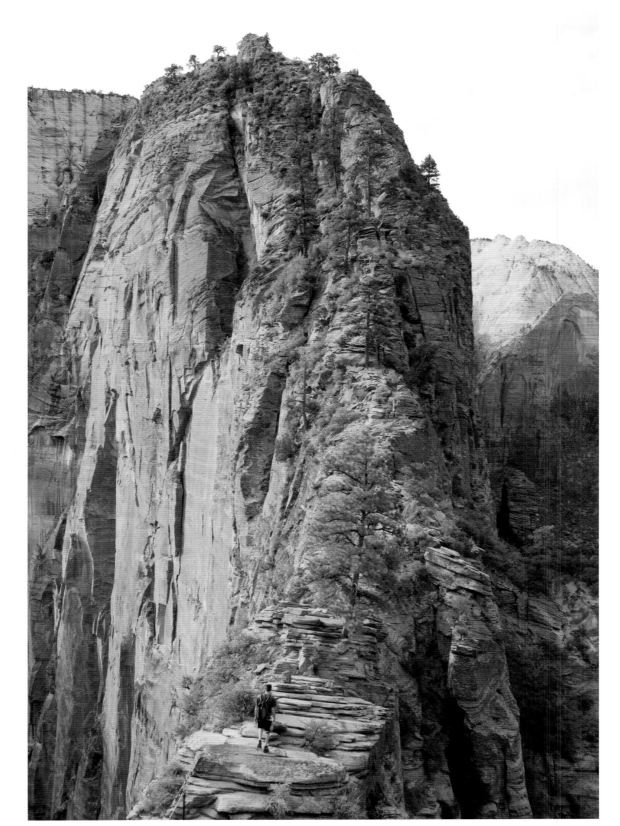

One of the most popular (and challenging) hikes within Zion National Park is the Angels Landing Trail. With a peak elevation of 5,790 feet, Angels Landing offers hikers a spectacular view of Zion Canyon.

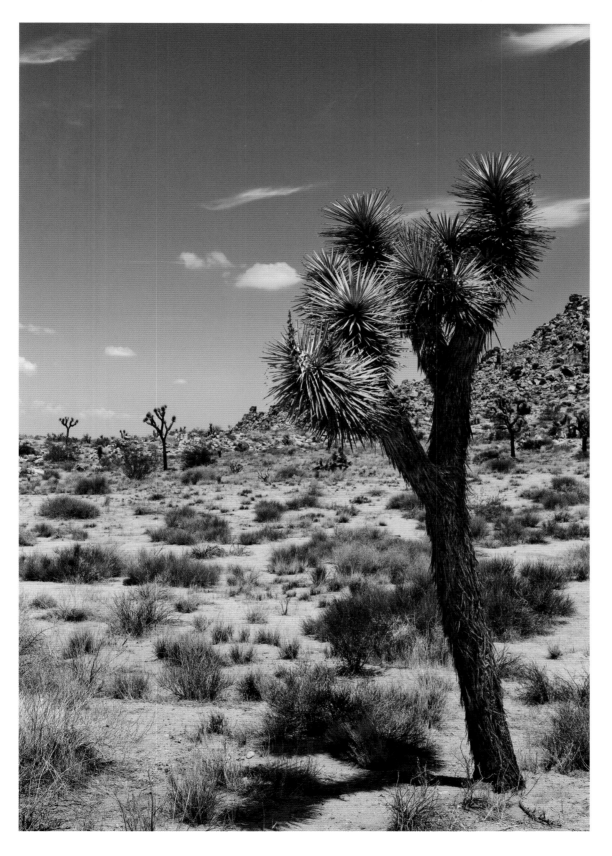

The northern reaches of the Mojave Desert extend into southern Utah. This distinctive ecosystem is home to the gnarled Joshua tree, a yucca that doesn't grow any-where else on earth.

OVERLEAF
Covering more than 3,700 acres, the salmon-colored sand dunes of Coral Pink Sand Dunes State Park are surrounded by red sandstone cliffs, brilliant blue skies, and thick pine forests.

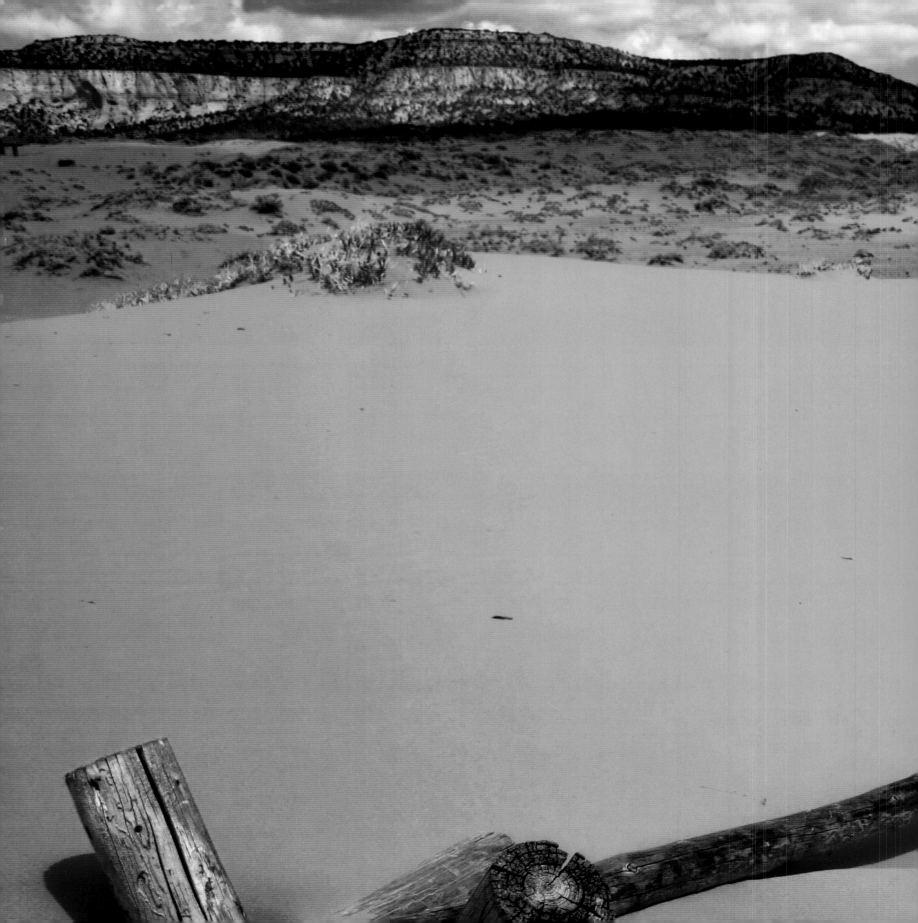

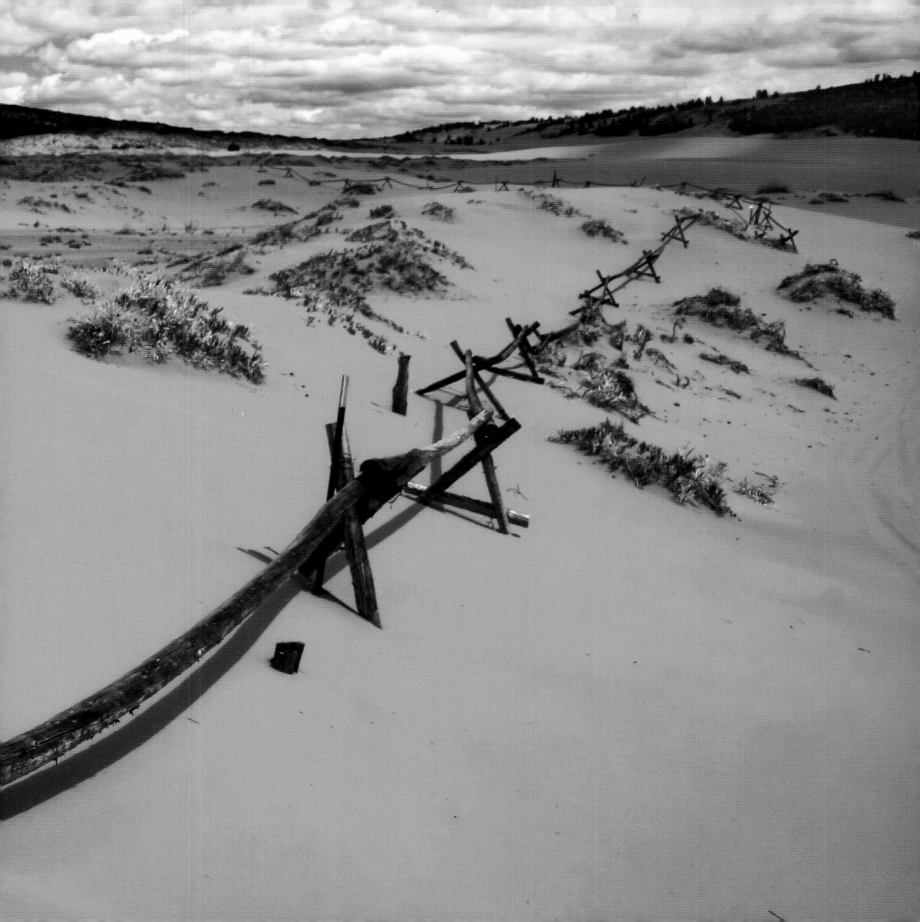

Photo Credits